Seeing Charleston

A Field Guide to Photographing
a World-Class City

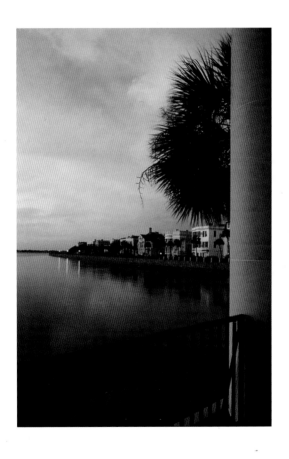

Written & Photographed By
Ron Anton Rocz

Ron A Rocz

THE JOGGLING BOARD
Legend has it that the idea for the joggling board came to South Carolina from Scotland in the early 1800s. The long board supported by rockers at each end allows two or more persons to rock together. This playful outdoor furniture became a common sight in the 19th century, gracing Southern porches, yards and piazzas. It was thought to be useful in easing rheumatism, aiding digestion and bolstering courtships. Some say that no daughter went unmarried in any antebellum house with a joggling board.

JogglingBoardpress

Published by Joggling Board Press
Joggling Board Press, LLC
P.O. Box 13029
Charleston, SC 29422
www.jogglingboardpress.com

Editor/publisher: Susan Kammeraad-Campbell
Associate editors: Douglas Bostick, William R. Campbell, Ph.D.,
 Tom Smith, Ph.D.
Senior designer: John Costa

First printing 2007
Printed in Hong Kong.

A CIP catalog record for this book has been applied for from the Library of Congress.

ISBN-13: 978-0-9753498-4-7
ISBN-10: 0-9753498-4-8

Dedication

I dedicate this book to my father and mother, who gave me my first Kodak box camera at the age of ten and the freedom to use it however I chose.

"We receive the light,
Then we impart it.
Thus we repair the world."
– Kabbalah

Preface

I know you. Even if we've never met, the fact that you've picked up this book tells me we have a lot in common. Like me, you find yourself in this amazing jewel of a city – a place of rare images. You have an innate desire to capture what you see. As you look around, the camera practically burns in your hand. I truly understand. It's the classic photographer's dilemma: so many wonderful pictures, so little time.

As an established photographer living in Charleston for more than three decades, I've spent thousands upon thousands of hours photographing this city. I have walked around, biked around, driven around – exploring Charleston's every photographic nuance and angle. I have returned to these carefully chosen sites again and again to shoot and re-shoot each image. I've photographed at all hours of the day and night, in every season of the year. From this experience, I wanted to share with fellow photographers ways to help make memorable pictures of Charleston.

So, whoever you are with a camera…
a visitor
or a local resident,
a tourist
or conventioneer,
a photographic amateur
or a professional shooter,
a user of film
or the latest digital camera…

… here is a field guide custom designed to enhance your adventure photographing the panoply of shapes, images, patterns, colors, textures and stories that make up Charleston, South Carolina.

You'll get the what, where, when and how to capture historic Charleston and its environs. I've selected some of my own favorite photographs from over the years; included some information on the historical significance of a location; and punctuated the book with quotes from famous photographers who have helped me along the way. To give you a point of reference in a city where time and history are very tangible, the dates of construction are listed in brackets next to named historic buildings.

This book will stimulate your eye and help you see Charleston with energy and creativity. In other words, it will help focus the artist's eye in you.

So here's an easy-to-understand field guide for adding that professional touch to your personal collection of Charleston images and to help you express creatively not just Charleston, but your view of Charleston.

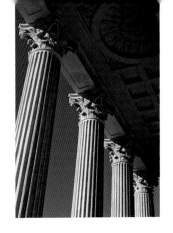

Contents

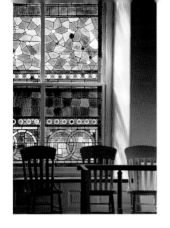

Meet the Author/ Photographer

B efore we begin, I'll tell you some about myself and how I came to know and love photographing Charleston. In the 30 years I've lived in this, "The Holy City" (homage to its many beautiful and historic church spires), I have developed a special love for travel, scenic and architectural photography. But becoming a professional photographer was a second career for me. It was a mid-life happening…evolving spontaneously, unplanned, incrementally, born of earlier artistic leanings and talent.

Thirty years ago seems like yesterday, when I wandered the windswept beaches of Sullivan's Island with my new Mamiya SLR, enjoying a simple hobby that turned into a passionate avocation and then, over time, a thriving business and new career. Photography found me more than I found it. Once the process was set in motion, the camera quickly took control of my life, a seductress. Other photographers I've encountered along the way have been similarly captivated.

My first career was in social services. I worked in race relations, poverty programs, mental health administration,

human resources and organizational development. My master's degree was in social work from Case Western Reserve University (1972). As a photographer, I am informally trained – I've had the benefit of occasional workshops, photo clubs and input from artist-photographer friends. Mostly, I've learned from doing.

My passion for photography soared as I photographed Charleston, then Bermuda, Iceland, Puerto Rico, Peru, Central and Eastern Europe. Of Hungarian descent, I've been inspired by famous Hungarian photographers. I have photographed extensively in Budapest and throughout Hungary. My work has been exhibited in the Hungarian Embassy in Washington, D.C., and by Malev Hungarian Airlines. I have photographed Prague, Slovakia, Poland and Moscow. More recently in Romania, I photographed the Roma people (Gypsies). Lately, my attention has been on the Mississippi Delta, "Land Where the Blues Began."

Two of my most notable clients have been the late CBS reporter Charles Kuralt and H.R.H. the Prince of Wales when each visited Charleston. My photographs have appeared in *National Geographic Traveler*, AARP's *Modern Maturity* and Northwest Airlines' *World Traveler*. My first book of photography was *The Churches of Charleston and the Lowcountry*, (USC Press, 1994), followed by *The Plantations of St. Bartholomew's Parish* (Colleton County Historical Society, 2005). My work is represented by Index Stock Imagery of New York and Chris Fairclough Worldwide Images in London.

My work also has appeared in major city arts festivals, fine art galleries, local and national magazines, tourist media presentations, posters, books, calendars, post cards, commercial web sites, and installations of interior décor for department stores, hospitals, health spas, restaurants, banks and military installations.

I also coordinate "Charleston Kids with Cameras," a program that gives inner-city youth access to cameras and mentors. They go out on field shooting sessions, edit images in workshops and see their work displayed in public exhibitions. Seeing the world through their eyes has been an amazing experience.

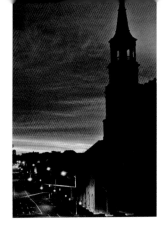

Starting Tips & Technical Stuff

1 Carry this field guide with you as you make your way around Charleston and the Lowcountry. It should fit nicely into your camera bag, pocket or purse for ready reference. Once you know your destinations, read it the night before – at home or in the hotel – to gather ideas for your shoot. Preparation makes a difference.

2 Go for what photographers call the "sweet light," which occurs in the early morning and late afternoon. Sweet light gives more rich and warm color. It also produces longer, more dramatic shadows, which add interesting contrast to photographs. You'll discover Charleston's shadows are especially prominent in its wrought-iron gates, fences, columns and lampposts. And if you want extraordinarily soft colors and the sweet light, rise before dawn, grab a cup of coffee, postpone breakfast, and take full advantage of the incredible pre-dawn tones. Work alone at that time, if possible, to be less distracted and more open and in tune with your surroundings.

3 Imagine and create beyond the standard, "post card" views. These kinds of images are pretty but common and predictable. Make room for more creative interpretations. As an example, consider moving up on the subject matter, simplifying the image, eliminating distractions, using the "less is more" principle.

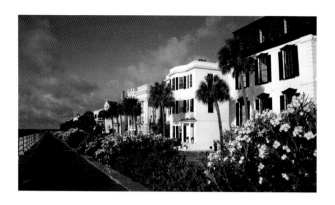

4 Remind yourself to carry equipment you may need, e.g. extra camera batteries, a tripod however small, and a flash if one is not built into your camera. If using a film camera, bring along some "faster" film, e.g. ISO 400 film, balanced for both daylight and tungsten light. The light could get dim, or you may find yourself wanting to shoot indoors. Otherwise, ISO 100 daylight film is the best, giving you the finest resolution slide or negative. For shooting at night, use fast-speed film.

5 Use a variety of lenses, from wide-angle to telephoto. Be creative with the lenses; play with them. Having options with lenses is necessary – especially when photographing Charleston's narrow streets. Know that wide-angle lenses can be used creatively for close-ups or for capturing close-up details with receding backgrounds. Telephotos are effective for long streetscapes, pulling structures together into compositions with tight repetitions. If you're working with a zoom lens on a point-and-shoot film or digital camera, the same principle applies.

6 Be brave, and get away from the "A" or "automatic" on your camera, whether film or digital. If you're not already knowledgeable about manual settings, take a little time to read up on them in your manual. Really, it's not that hard. Varied metering, aperture settings, camera speeds and focusing depths make a difference.

Heart of the Historic District

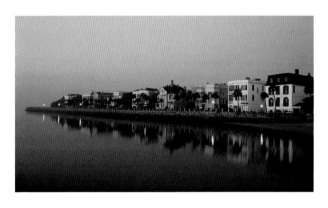

East Battery Waterfront & Houses

Charleston's **East Battery** waterfront is the city's signature view. It contains some of the most distinctive elements of Charleston: antebellum homes, a harbor view and palmettos lining flagstone walkways. I bike ride by this area every other morning during my early exercise (Look for me. I'll happily stop so we can chat). It's ideal to shoot from a spot overlooking the entire scene. Here are some tips on how to capture this wonderful, ever-changing vista.

Rise early, grab a quick cup of coffee, delay breakfast and head to the upper part of **East Battery** (that's on the Cooper River side of the peninsula). Stop along **East Battery Street** where the **Charleston Yacht Club** and **Historic Charleston Foundation's headquarters** (called the "Missroon House") share an entry drive, and go into the large parking lot. Walk to your right, toward the water. From here you'll find a grand view of the **High Battery**, reflected in **Charleston Harbor's** sparkling waters. My guess is you've missed this inclusive vista before (which incorporates the water) if you've only walked along **High Battery**. It's one of my

favorite spots to sit undisturbed, watch, meditate and create superb photographs.

One option is a straight-on horizontal shot at the water's edge. Another is to use the on-site palmettos to frame the image. Or walk up onto the portico of **Charleston Yacht Club** hall (on your left) and use its columns for framing.

Most important of all, plan to arrive early, even before the sun rises, if you can manage it. When you do (and if the gates are open) a colorful treat is in store for you! About 40 minutes before the sun edges over the horizon, especially in the non-summer months, marvelous glowing colors wash the sky and water. Shoot with a tripod and fast film so you can handle longer exposures. Stay awhile. As the sun comes up, catch the rich golds painting the houses in warm hues. And, all this will be brilliantly reflected in the water! If the morning is cloudy, return to capture this particular image on another day. Once accomplished, however, you will have created one of your most memorable shots of Charleston.

If this location is not accessible, stroll along the flagstone walkway at water's edge (called "**High Battery**") and easily photograph the string of antebellum homes from almost any vantage point – though without the water reflection. One of my favorite spots is close to the intersection of **East** and **South Battery** (where the historic park called **White Point Gardens** begins), looking north. In the summer months, when the oleander bushes are in full bloom, this view is unforgettable. Again, early morning light is ideal.

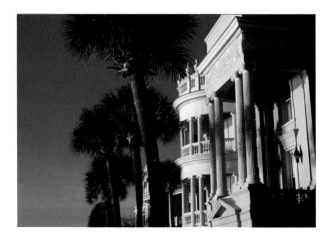

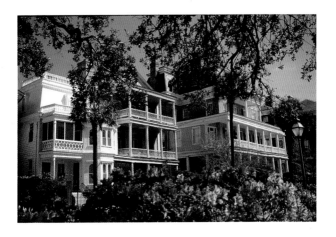

South Battery Houses

Along **South Battery**, the antebellum houses stand like soldiers facing **White Point Gardens** and the **Ashley River** as it ebbs and flows into **Charleston Harbor**. They project a presence that seems to defy the passage of time from the pre-war plantation/maritime lifestyle that created them. This complex and telling scene is unique to the American South and is a photographic "must" in telling your visual story of Charleston.

The challenge here is capturing this militant parade of historic homes without the distraction of modern cars parked along **South Battery** or the invasion of slow-moving tourist vans. Here are a few secrets and angles I've discovered.

First, consider the time of year in your photographic strategy. Springtime offers some especially attractive views and compositions if you are willing to loosen up and stretch your body some. Across the street

"I learned to step back so I could make an image that was sharp and refined and had deep space in it. As I stepped back, I began to see a new kind of image."
– Joel Meyerowitz

from the houses, you will find some modest-sized azalea bushes at the perimeter of the park. At midday, the sun highlights these azaleas, and you can use them creatively in your composition when photographing these grand houses. Position yourself down low behind those azaleas on your hands and knees (even lie flat on your chest if necessary). The azaleas help to camouflage the modern vehicles which seem so incongruous against the historic architecture. Now, look up toward the houses. See the picture? Nice, isn't it? Don't worry about what the wandering tourists may think as

you sit or lie on the ground, for your pictures will be worth it. Once finished, rise up, dust yourself off and move on!

For even more exacting results, shoot this scene with your camera on a tripod in its absolutely lowest position, and you will have the option of varying "depths of field." If you're familiar with this technical term, you're ready to go. If you're not, learn about it soon, for it can make an immense difference. For now, refer to the brief explanation on page 56.

Another version of this scene is to shoot later in the day with the afternoon sun behind you. Position yourself near the corner of **South Battery** and **King Street**. Here, a number of possible compositions can be found. Once again, avoid including the vehicles. One great shot requires a telephoto lens and a tripod. Take up a position on the north side of **South Battery Street**, just east of the **King Street** corner, and zoom in on the fascinating repetitions of the facades and porticos. Note how the architectural columns line up one after another. Repetition of interesting patterns is one of the hallmarks of superior photography. I used this technique once while photographing this very scene for *National Geographic* magazine. If you prefer a wider view, cross the street, walk into the park, and frame your scene using a few lampposts in the foreground (along with some shrubbery to block out the cars). Wait a short while, and, with any luck, a horse and carriage will come along, adding more action, color and interest to your creation.

We shouldn't move on without pausing first at **Two Meeting Street Inn**. This 1890-92 Queen Anne style mansion has become an iconic symbol of Charleston's beauty, grace and charm. If you happen to be a guest in this excellent bed and breakfast, you will have ready access to the porch and garden with its interesting views and angles. Otherwise, shoot from the public sidewalk and use the Inn's wrought-iron gates on the **Meeting Street** and **South Battery** sides to frame creative compositions.

White Point Gardens

White Point Gardens has often been described as the place "where the **Ashley** and **Cooper rivers** flow together to form the Atlantic Ocean." It is located at the southernmost tip of the Charleston peninsula. From this location in 1861, residents of Charleston literally watched the shots fired from James Island onto **Fort Sumter**, signaling the start of the

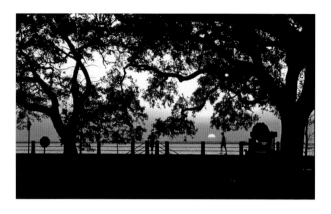

War between the States. Today, the shooting that goes on is strictly photographic. The park is lined with historic cannons and statues, an old bandstand at its center. The harbor itself is in constant motion with maritime activity. The best creative possibilities are found in the earliest hours of the day when dawn's illumination streams in from the harbor.

At dawn and just before, the park's lamps are still lit, adding purpose to arriving early. The lamps inside the park line pathways sheltered by enormous oak trees, adding an element of mystery and romance to compositions you might create here. If it is foggy, the effect is all the better. The lamps cast a soft glow that can be captured in black and white. If you shoot in color, you'll pick up the muted blue-green luminescence. This, combined with the early-morning tones of dawn breaking over the harbor, will produce subtle, pastel hues. The combination can produce powerful images.

Try shooting on the **South Battery Street** side, just into the park near the bandstand, aiming your camera toward **East Battery** and the dawn's light, then the rising sun. From this spot, especially when using a telephoto lens on a tripod, you can capture in one composition the streetlamps, oak trees, silhouettes of cannons and statues, and the railing atop **High Battery** walk. Boats of one variety or another may pass into the scene. And as a bonus, you might encounter some early morning fishermen with crab nets or fishing poles working along **High Battery** walk.

"The act of making a photograph is less a question of *what* is being looked at than *how*."
– Margaret Atwood

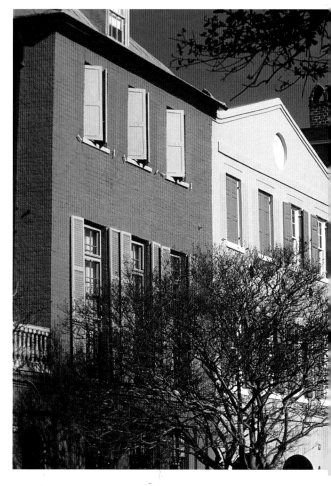

Rainbow Row

The string of 14 multicolored facades built in the 1740s along what is now **East Bay Street** is widely known today as "**Rainbow Row**." This image – unique in the continental United States – has helped make Charleston famous. It's

one of my sentimental favorites. And it was here that I photographed Charles Kuralt, upon his request, for the jacket cover of his book, *Charles Kuralt's America*.

Rainbow Row is just a block south of **Broad Street** and the **Customs House**. Because it faces east, morning is the

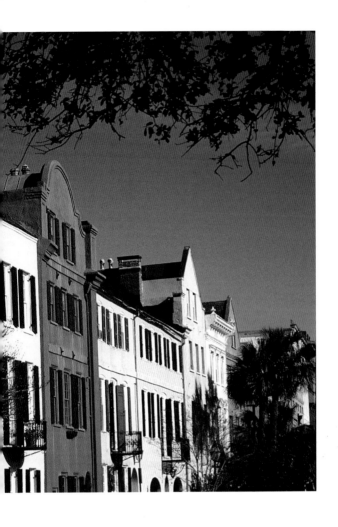

best time to photograph it. Allow enough time for shadows
from the structures on the opposite side of the street to
clear the scene before shooting. Not surprisingly, this site
is a long-time favorite for local artists and photographers
with its color and old world architecture. Painters have the
advantage of portraying this setting in a myriad of ways
without the ubiquitous autos parked along the street in
front of the doorways. Still, we photographers need not be
deterred. Here are a couple suggestions.

For one view, stand on the sidewalk or parking strip im-
mediately in front of the houses and view the row looking
either north or south, eyeing it vertically, using varying focal
lengths – whichever one suits your creative eye. Catch the
rhythm of the colors and the repetition of the doorways.
Possibly include one of the lampposts to the right or left
of your picture, opposite the architecture, and with the

sidewalk receding into the distance. Of course, pedestrians are common in this area, so you'll have to be careful if you don't want to include them in your shot.

For a panoramic view of **Rainbow Row**, wander down to the corner of **East Bay** and **Tradd** streets. Stand on the opposite side of the street, and view the whole scene horizontally. Raise the camera just a bit to exclude the cars. Sorry to say, you will not get the doorways in your photo, but it's the rainbow of colors and the shape of the facades that create the interest in this image. From this point of view, especially with a slight wide angle (e.g. 28mm), you should achieve good results. If you stand back far enough, you can frame the scene with tree limbs hanging above you.

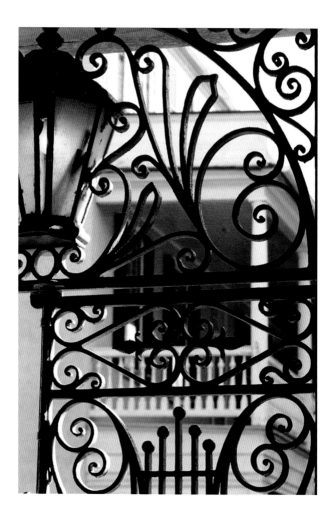

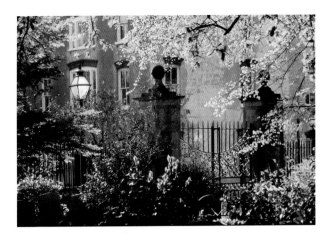

The Queen & Church Street Area

This little intersection in the heart of Charleston's historic district is a photography buff's bonanza. Here, at almost any time, subject matter abounds: the **Dock Street Theater, St. Philip's Church** and its two cemeteries, the **Footlight Players Theater**, the **Pink House Gallery**, cobblestone streets and quaint old houses – all with horses and carriages passing by. What's not to love? You'll want to make a complete photo tour. But first, let's look at what times of day are best for which subjects.

Best Morning Subjects

The **Dock Street Theater**, formerly the **Planters Hotel** (1800) built on the site of Charleston's first stage theater (1736), is best photographed in the morning. The light plays nicely on its wrought-iron balconies and textured stucco walls. You might also catch a horse and carriage passing by. Don't be put off by any vehicles parked in front of the theater. They'll come and go; it's only a temporary loading zone.

If the **French Huguenot Church** (1845) is open across the street, enter and enjoy its gothic architecture, with light beaming in through the south windows. The attendant may give you access to the balcony for a full view and may even turn on the lights to give you better illumination. Use a tripod and a slow shutter speed if light is limited.

"To compose a subject well means no more than to see and present it in the strongest manner possible."
– Edward Weston

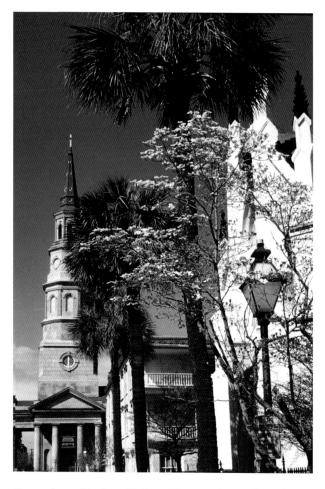

Go south one block to **Chalmers Street** and view the early Charles Town tavern (1694), now known as **Pink House Gallery**. Here, options abound, which we will discuss later.

Next, backtrack up **Church Street** to **St. Philip's Church** (1838). Note how the church's intricate gate, massive doors, columns and steeple offer boundless possibilities photographically. If you're fortunate to be here in the springtime when the dogwoods and azaleas are in bloom, you'll have some colorful enhancements for your photographs. At Christmas time, you'll find appealing decorations of natural fruit at the top of the wrought-iron gate. Adjacent to the church at the rear is the cemetery. Look back toward the street to take in the early rooftops and chimneys atop the little houses along **Church Street**, best composed with a telephoto lens. At the same spot, during the early spring, note the dogwoods blooming next to the church's columns. Carriage drivers enjoy telling visitors, "Locals say these

dogwoods were apparently planted over the grave of a fast woman." Cross the street and enter **St. Philip's** other cemetery, looking back around to the steeple. If there are spring blossoms, they will be backlit by the morning sun, with the steeple dramatically silhouetted.

Best Afternoon Shoots

By this time of day, the **French Huguenot Church** is well lit, and in springtime, the dogwoods around it frame the church for a lovely view. For another creative approach, stand on **Church Street** next to the church's cemetery fence (directly across from the theater entrance) and, with a wide-angle lens, photograph the church itself with bits of the fencing and tombstones to the right. For yet another view, cross the street, stand on the portico of **Dock Street Theater**, and compose a view of the church through the theater's arches and columns.

Return to **St. Philip's Church**. If there's afternoon sunlight, it will give you interesting shadows behind the short, front gate. And, the columns will offer some fine, semi-abstract possibilities when viewed from across the street. Play with that! Then venture again into the cemetery behind you and, at springtime, view the steeple through the blossoms. The steeple surrounded by azaleas, dogwoods and hanging Spanish moss adds a dimension that is quintessentially Charleston. For a nice horse and carriage shot with most of **St. Philip's** in the picture, return to **Church Street**, walk just a few feet north of the church's front entrance on the west side of the street. Position yourself with a wide-angle lens and wait for a carriage. They come by frequently.

These tips are hardly all-inclusive of the myriad artistic and creative photo possibilities surrounding this intersection, but they will definitely get you started. Most importantly, seek out the imagery you find captivating.

"On every trip to a new country or city… I manage to find a little time to go wandering about by myself… looking for the unexpected. And seldom am I disappointed."

– Alfred Eisenstaedt

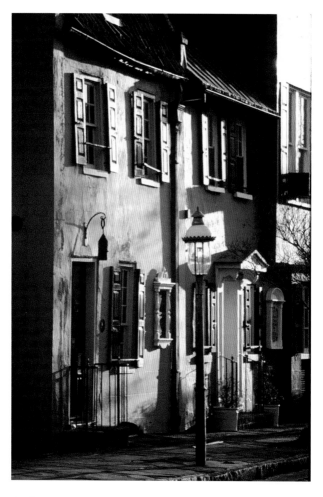

Pink House

Photographing **Pink House** is a marvelous chance not just to capture an object but to be creative in doing so. The former tells *what* is there, while the latter relays a *feeling* about it. The great thing about **Pink House** is you can move around in it many ways and at varying times of the day.

Look at the house up close and from afar. Standing on the sidewalk right in front, view it with the sun coming at you as well as behind you. Picture it from across the street with lampposts and cobblestones. If it's summertime, glance down at the cobblestones and note the fallen, pink petals of the crepe myrtle lying in the cracks. Use all those charming Charleston details to enhance your **Pink House** image.

A great time of the year to photograph **Pink House** is between May and July; that's when the summer sun reaches

the front of the building. At this time, I find that the early morning and late evening light produces defining shadows and reflective glare on the structure, especially on the shutters, making for an appealing and artistic image. Also in the summer, the crepe myrtle tree immediately in front of **Pink House** is in full bloom, adding a dash of lavender to the picture. And at night, especially after a rain when the cobblestones are wet and reflective, you can compose a delightful image, using the street lamp as a focal point.

Finally, consider a photograph from inside **Pink House**. The third story window offers a delightful view overlooking the Historic District toward **St. Philip's Episcopal Church**. Meet the manager, make a little purchase, and then kindly ask if you might take a shot through the cold-rolled glass window upstairs. You'll enjoy the very narrow stairway as much as the quaint view.

[IN FOCUS]

Side lighting

Side lighting brings out shape and texture, creating shadows that dramatize the objects in view. Avoid the high overhead light that occurs at noon, because it wipes out detail and shadows. Early morning and late evening sunlight provide pleasing side lighting.

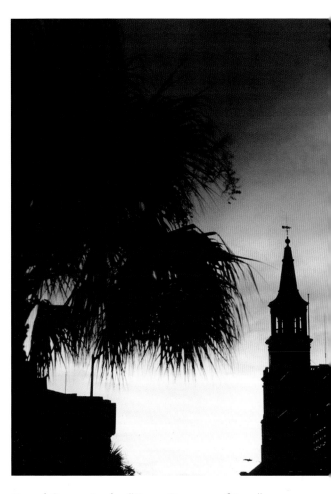

Broad Street & the "Four Corners of Law"

Traditionally, **Broad Street** was the center of Charleston's busy 18th- and 19th-century legal life. This throbbing heart of town featured a few cafés and tobacco shops, but it was primarily where politics and business met and made history. Today, the street mostly hosts art galleries, finer restaurants, upscale boutiques, bed and breakfast inns, and expensive apartments and condominiums. Nevertheless, the street's historically significant architecture *par excellence*, tasteful business signs and colored stucco constitute a busy scene, all underneath not only the steeple of **St. Michael's Episcopal Church** (1752-1761) but also the cupola of the **Old Exchange and Customs House** (1771). The most commonly photographed "postcard" view of **Broad Street** is from its lower end, facing westward toward **St. Michael's**. If you stand on the north side of the last block of **Broad Street** and use a telephoto lens aimed above the parked cars, the composition will pull together the building

Silhouettes

Dramatic silhouette images where the foreground elements are dark and the background is shot with color are relatively easy to achieve. Simply meter the light in the far background, e.g. a sunrise with color. This will cause the foreground subject matter to appear black, offering a stark contrast to the colors in the distance. Use the spot meter feature, or meter for the overall scene and then "close-down" the aperture about 2 f-stops. If you have a preview function on your camera, you can view the image prior to making the exposure and then adjust as needed.

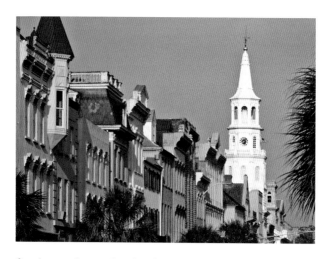

facades on the south side of **Broad** with the white steeple to the right. This shot works best in the morning when the steeple is sunlit and in the summer months when the sun is far enough to the right to illuminate the facades. Try to include a palmetto tree or gas lamp to frame the view.

A similar view from the other direction can be composed at the upper end of **Broad Street** near **King**, looking east. And if you rise early enough, this is a great vantage point for silhouetting **St. Michael's** against the dramatic colors of dawn. Once the sun has risen, watch for golden light reflecting off the front windows and shutters of nearby buildings.

A motto for Charleston has been *Aedes Mores Juraque Curat*, meaning "She guards her customs, buildings and laws." This motto is reified in the "**Four Corners of Law**," a phrase locals use to describe the intersection of **Broad** and **Meeting** streets. Its history reaches from the 1690s, when South Carolina was a colony, to the famous school desegregation case of the 1950s. The four buildings on this intersection represent everything required in a civil society. **St. Michael's Episcopal Church** represents God's law, the **U.S. Court House** and **Post Office** represent federal law, the **Old State House** represents state law, and **City Hall** represents local, municipal law. Tidy, isn't it, all in the same location? But pulling all four of these structures into the same frame is nearly impossible. It's been done with aerial shots. Short of hiring a pilot, try using an extremely wide-angle lens, almost a fish eye, from the covered portico

> "Everything that surrounds you can give you something."
> – Andre Kertesz

of **St. Michael's Church** or from the front stairs of the **Post Office**. Otherwise, individual photos of each corner, placed together in an album, will have to suffice for depicting an intersection unique in America.

And while you're on **Broad Street**, don't miss the **John Rutledge House** (1763) at **116 Broad Street**, now a bed and breakfast inn. Its elaborate wrought-iron fence, railings and balcony offer many photographic possibilities – including some creative close-ups. The building faces south, so any time of day works.

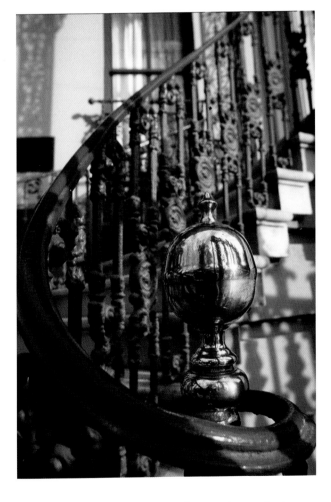

"There is only one moment when a picture is there, and an instant later it is gone forever. My memory is full of those images that were lost."
– Margaret Bourke-White

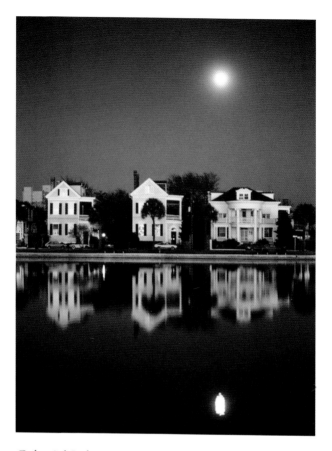

Colonial Lake

Colonial Lake is a city park and one of only two small "lakes" on Charleston's peninsula. Once a millpond at the edge of the city, it was transformed into a park in the 1880s as Charleston's residential district expanded around it. The park is a favorite area for walkers, joggers, casual bikers, dog-walkers, bench-sitters and the occasional fisherman and shrimp net caster.

Your best view here, always during afternoon and evening hours, is from the west side (**Ashley Avenue**) looking eastward over the lake to the large houses – some impressive Victorians – extending along **Rutledge Avenue**. At dusk, the sun can sometimes bathe these homes in a gold luminescence.

But best of all, if you plan ahead, terrific landscape photographs can be taken from this spot with the full moon rising up in the eastern sky behind the houses, all reflecting in the lake.

Another similar scene at **Colonial Lake** occurs "once in a blue moon," so to speak. During the winter months, the post-sunset sky can glow with alluring colors – soft pinks, lavenders and violets. Thirty or forty minutes after sunset on a clear day, this colorful glow, along with evening house lights and a full moon, create a wonderful scene. And remember, the moon moves, so any exposures longer than 20 seconds will result in an elongated moon in your picture. Keep your exposures below 10 seconds and you'll avoid this distortion. If your film speed is higher than ISO 100, the exposure time can be reduced.

"Chance favors the prepared mind."
– Ansel Adams

[IN FOCUS]

Capture The Moon

The very best full-moon-rising landscape photography, here or anywhere, is accomplished one day before the day of full moon! Why? That's when the landscape is still illuminated by ambient light from the setting sun, making the landscape in the foreground softly visible with the rising moon. On the day before a full moon, the moon actually rises an hour before the sun sets, producing marvelous ambient light. On the day of the full moon, the landscape is dark by the time the moon rises high enough over the horizon for your photograph. So watch the moonrise schedule and weather report to see if you can pull off this kind of photograph.

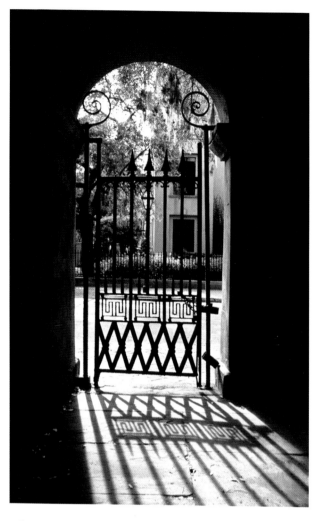

The College of Charleston

The College of Charleston (1785), the oldest college in South Carolina and the 13th oldest in the United States, is delightfully photogenic at the campus interior. The area known as "**The Cistern**" was originally called the campus green. The cistern was constructed in the mid 1850s to provide water for the campus. Framed by massive live oak trees, this special spot serves as a place of grandeur, beauty and memory, as the location for graduation exercises.

Near **The Cistern** is an old square situated between **Randolph Hall** and **The Porter's Lodge**, surrounded by oak trees and a stucco wall. This is a great place to be creative as a photographer.

The Porter's Lodge, facing **George Street** and across the square from **Randolph Hall**, is artistically appealing. Its architecture, stucco textures and elaborate wrought-iron gates offer varieties of shape, form, texture and angle for creative compositions, both close-up and wide-angle. On Sunday mornings, when the campus is quiet, you can capture the horse-drawn carriages when they halt in front of the lodge for the drivers' narrations.

Randolph Hall is also worthy of notice with its aqua blue shutters mounted on antiquated textured stucco. Photography loves those old textures! And up on the portico, many angles will present themselves to you, especially in the earlier morning light. The repetition of the huge columns and deep shadows makes for strong images.

"You do not have to imagine things. Reality gives you all you want."

– Andre Kertesz

Focusing Closer Up

Cobblestone Streets & Alleyways

The cobblestones of Charleston were originally ballast stones from seafaring vessels. Local folklore has it that they are revered and protected to the point that, if ever dug up by city workers, they are replaced in exactly the same spot. It's a good story, but many of us locals doubt its truth.

The best cobblestone street in Charleston of any real photogenic quality is **Chalmers Street**, and the best location for you is near **Pink House**. From this spot, looking west, you will see horse-drawn carriages cross **Chalmers Street** on **Church Street**, making possible a composition with cobblestones in the foreground. A similar view of the cobblestones and a passing carriage can be seen from the opposite direction, looking eastward toward **State Street**. These are quintessential Charleston scenes.

One lesser-known Charleston alleyway that remains cobbled and has bluestone is **Longitude Lane**, running from **East Bay** to **Church Street**, just a few blocks south of

Rainbow Row. The **Church Street** end of this lane is most photogenic when you include the smaller houses and their quaint door lamps.

Lodge Alley, another narrow alleyway, is paved with brick. It includes a wonderful view of **St. Philip's** steeple, especially in the morning, from **East Bay Street**. If you shoot this alley very early, looking east from **State Street**, and in the summer months when the sun is more directly in front of you, the resulting photograph will be filled with dramatic, golden, back-lit contrast.

Nearby is **Philadelphia Alley**, running northward from **Queen Street** next to the **Footlight Players Theater**. Constructed of cobblestone and granite blocks, the dim alley is overhung with trees. And further down the peninsula is **Stoll's Alley**, especially worth a look in the springtime when lush with wisteria.

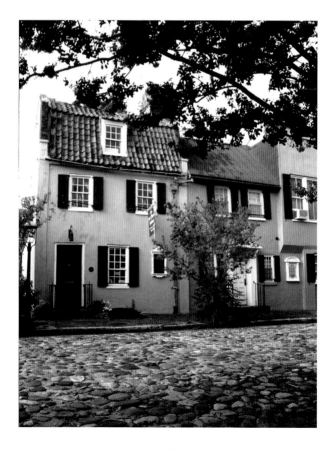

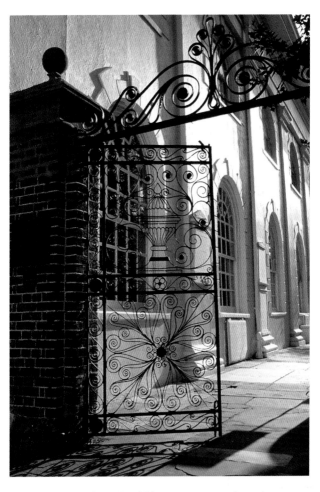

Photograph Charleston's cobblestone streets early in the morning or late in the evening when the gas lamps are lit. And, particularly if there's fog, you will be pleased with the results.

Wrought-Iron Gates

Charleston possesses what is arguably the largest, historic collection of urban wrought iron in the United States. The "collection" represents three centuries worth of work by master blacksmiths. The craft deserves your close attention and is a "must" for your photography of Charleston.

You need to employ the right technique to fully capture this craft's character, charm and design. When you photograph wrought-iron gates, you want contrast between the wrought iron and its background, to bring out the gates' designs. For instance, if you shoot a gate with dark greenery in the background, you will have too little contrast to bring out the gate.

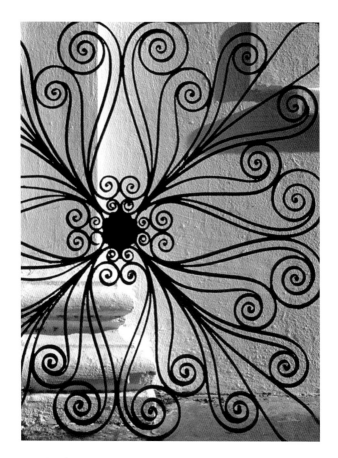

Here's what I suggest you do. Position yourself to find an angle that provides a lighter background – such as light-colored stucco of a nearby wall, the whites of a painted porch, or the brightness of a sunny walkway. Such backgrounds will make the gate stand out in your photograph. An additional technique to highlight the intricate gate designs is to shoot them with their shadows falling in one direction or another. The shadows repeat and accentuate the designs, bringing out the blacksmith's artistry.

Some of my favorite gates are those at **St. Michael's Church**, enclosing its cemetery on both **Meeting** and **Broad Streets**. The **Broad Street** gate is best shot in the middle of the late morning, when the sun casts grand, long shadows. The **Meeting Street** gate is best photographed shortly after sunrise, when the church wall is well lit in the background, and shadows fall on the flagstone in the foreground.

"I do not believe that something reports itself in a photograph. It is redrawn."

– Richard Avendon

You'll also enjoy working with the magnificent gates at **St. John's Lutheran Church** (1817) at **10 Archdale Street**. This large set of gates between high columns is some of the finest wrought iron in Charleston. The setting yields endless creative perspectives, all in the afternoon sun. You can view them from the street side or from inside the gates, standing on the black and white checkered portico. A great variety of angles will reveal themselves, from wide to tight. Don't arrive too late; the gates are frequently closed by late afternoon. If the gates are locked, you can reach this portico by entering through the **Unitarian Church** cemetery. Believe me, pursuing images in this location is worth the time and effort. It's tremendous! I've biked there hundreds of times with my camera, each time gathering new images. One was my best selling shot for years.

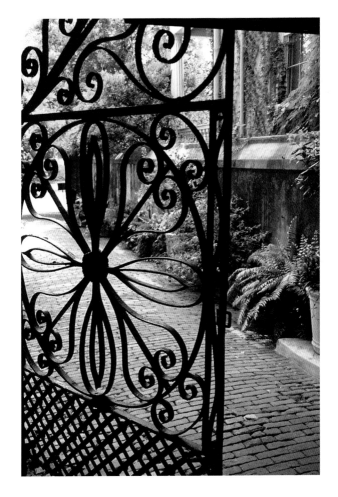

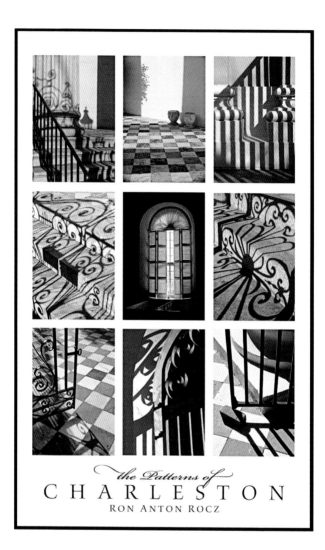

Shadow Graphics

Walking the streets of Charleston, you will encounter
a "family of elements" – marvelous wrought-iron gates,
balconies, lamps and lamp posts, Greek columns, cornices
and porticos. Look carefully, especially in the early and late
hours. Shadows from these elements appear everywhere,
accentuating and repeating their patterns and designs. These
shadows can translate into very appealing graphic studies,
adhering to the idea that more can be said with less.

I have been gathering these graphic shadow images year after
year and have found about every cast shadow "under the
sun" in Charleston. Well, okay, maybe not *every* one, but
almost! My files are filled with hundreds of these images,
like shells gathered over the years from beach walking. Now,

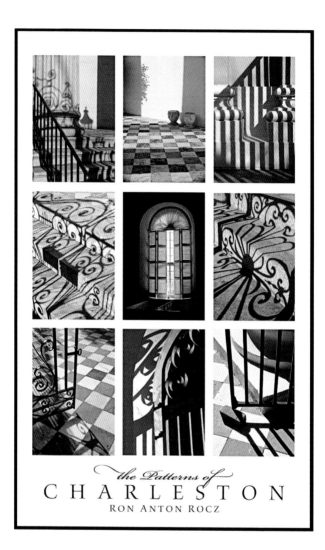

Shadow Graphics

Walking the streets of Charleston, you will encounter
a "family of elements" – marvelous wrought-iron gates,
balconies, lamps and lamp posts, Greek columns, cornices
and porticos. Look carefully, especially in the early and late
hours. Shadows from these elements appear everywhere,
accentuating and repeating their patterns and designs. These
shadows can translate into very appealing graphic studies,
adhering to the idea that more can be said with less.

I have been gathering these graphic shadow images year after
year and have found about every cast shadow "under the
sun" in Charleston. Well, okay, maybe not *every* one, but
almost! My files are filled with hundreds of these images,
like shells gathered over the years from beach walking. Now,

I invite you to find some for yourself (Hunting is half the fun!) and to work with them in your own way.

No special tips exist for this kind of photography, other than to unleash your innate sense of design and composition on the subject matter you find. That being said, keep a lookout for black and white checkered porticos and walkways. Look for wrought-iron gates in front of stairways, entries and gardens. Lift your eye to the occasional balcony, throwing shadows onto stucco walls. Watch for shadows from lampposts, columns, piazza railings and any combination of these elements. Use early or late light, when the shadows elongate. Adjust a gate if need be, moving it in or out, to achieve the desired effect. You may have to brush away some leaves, twigs, weeds, cigarette butts and who knows what. And use your hand or hat or something, if your lens has incoming glare. All of Charleston is your oyster with images to harvest. Enjoy.

Having said I would leave you to the hunt, I would be remiss not to steer you to a few "primo" locations. **Hibernian Hall** (1839-1841) at **105 Meeting Street**, best shot early in the morning; **St. Johannes Lutheran Church** (1842) at **48 Hasell Street**, gate and stairs, best at mid-day; **South Carolina Society Hall** (1803-1804) at **72 Meeting Street**, railings and stairs, only in the afternoons; and perhaps the choicest of all, and my absolute favorite, the portico, gates and columns at **St. John's Lutheran Church** on **Archdale Street**, only in the afternoons. On this latter location, if the gates are locked, enter from the churchyard by way of the **Unitarian churchyard** and **Gateway Walk**.

Of all these graphic shadow images I've shot, nine of them were combined into a poster, "The Patterns of Charleston." Create your own artistic combinations. If you are framing or otherwise displaying your work, group them in twos, threes, fours or any number to give a strong effect.

"I never had to go very far for subjects – they were always on my doorstep."

– Andre Kertesz

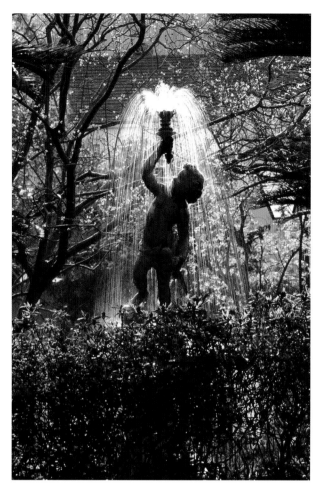

Fountains

The majority of graceful fountains in Charleston are tucked away in private gardens, hidden from public view. Sorry about that. But a few of these can be seen from the street, such as at **31 Meeting Street**. This fine fountain sits in the middle of a lush garden and features a cherub holding up a vessel. Behind it is a slight view of a large Charleston single house. In the springtime, azalea blossoms are abundant. Viewing the scene, I find it follows my notion about "threes." A photographic composition is often better if three important elements stand together. If it contains only two, find a third. Here, for example, we have the statue, the falling water, and the house and/or the blossoms. If you go in the late afternoon, the waters of this fountain are delight-fully backlit.

Two public park fountains are located in **Waterfront Park**, which stretches along the **Cooper River** side of the Charleston peninsula. One is the **Pineapple Fountain** at the center of the park. The pineapple is a symbol of welcome. When viewed from its east side looking toward the city, the top of the steeple of **St. Philip's Church** peaks above it. The other fountain is at the park's main entrance, at the head of **Vendue Range**. It features 16 high-water spouts spraying from the ground level into its center. An exciting time to photograph it is in the early morning, when the rising sun provides striking backlighting. You can also include the flagpoles and the pier shelter behind the fountain – all in silhouette. What's entertaining and great fun is photographing this fountain in the heat of summer, when children gleefully splash about under the cooling spouts.

Another photogenic and more antique-looking fountain is in **Marion Square**, on the **Meeting Street** side. It's immediately across the street from the yellow **Citadel Square Baptist Church** (1855). If you get down low beside the fountain and aim upwards with a wide-angel lens, the towering steeple adds a grand, sky-piercing background. And if you position yourself on the opposite side of the fountain looking west, the steeple of **St. Matthew's Lutheran Church** (1872) on **King Street** gives a striking background. Both of these angles also work well at night when the steeples are lit. Just remember to use your tripod and a slow shutter speed.

Finally, seek out the tall, cast-iron fountain in front of the **U.S. Courthouse Annex** (1987) on **Meeting Street** at **Broad**. I like the view gained by standing behind the fountain and looking up at **St. Michael's Church** and its grand, white steeple.

[IN FOCUS]

Make Water Velvety

The slower the shutter speed (especially down around ¼, ½ or one second), the more the moving waters take on a soft, velvet-like appearance. For that effect, use your tripod. Higher camera speeds freeze the water's motion, giving an entirely different look. Which way you do it depends upon your preference.

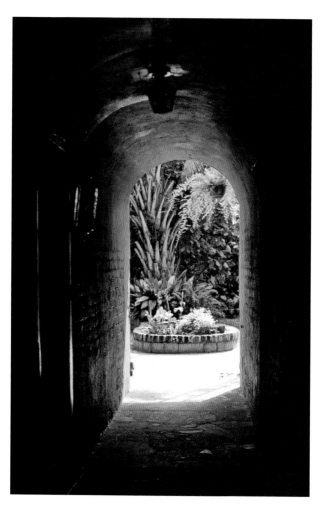

Arched Entries to Gardens

A delightful feature you will discover as you stroll the streets with your camera is the street-level arched entryway, the kind that creates a "tunnel" effect from the sidewalk into a private garden to the rear. The best of these arched entryways are at **24 State Street** and, nearby, **23 Queen Street**. Others that sometimes work, when lighting conditions permit, are **20** and **28 Elliott Street**, **24 Queen Street**, **91** and **99 East Bay**, and **27 State Street**. Compositionally, the archways are perfect frames for the garden foliage at the rear. In some, the tunnel includes a picturesque hanging lamp. Simple suggestions for these photographs are first, find one where the garden is in presentable condition; second, find one when sunlight is illuminating the rear garden; and third, expose for just the garden.

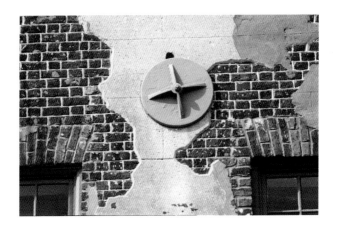

Those Telling Details

Photographs of the smallest details can say as much about a city as full streetscapes or sweeping skylines. And in Charleston, this is especially true.

Take, for example, those curious iron heads of metal earthquake bolts found high on the exterior walls of many Charleston brick and stucco buildings. After the Earthquake of 1886, these "reinforcements" for surviving masonry walls were installed extensively. They were sold in a variety of shapes – ovals, stars, crosses, diamonds, lion heads and crisscrossed irons. Modern engineers tell us their structural value is actually nil, but they were installed to squeeze old buildings back into shape after the earthquake of 1886, a traumatic and deadly event. Today, they can be photographed with the help of a telephoto lens, to form a collection of images that help tell a story of Charleston's long experience with destructive forces.

[IN FOCUS]

From Dark to Light

When shooting an archway into a garden, expose for just the garden. An overall average metering might result in the garden being over-exposed. A "spot" or "centered-weighted" meter helps the situation. Center-weighted is an exposure made only through the round circle in your viewfinder. Most cameras have it. You can set your camera for either spot or center-weighted exposures.

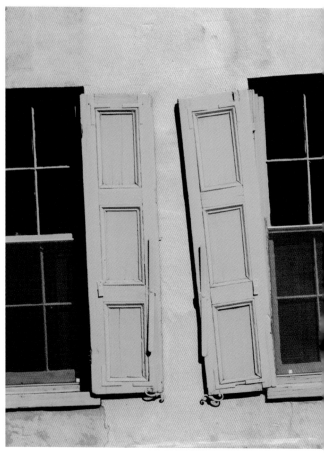

Other telling details include the many handsome brass door-knobs and knockers. They are polished regularly by dutiful housekeepers who've been performing this rite for many, many decades. As the saying goes for earlier Charlestonians, "Too poor to paint, too proud to whitewash, but the brass always gets polished." So they stand as a reminder of the century after the "War of Northern Aggression," when the Charleston elite had little money for house maintenance but

enough for housekeepers to polish the brass. Though now rather scarce, antique brass adornments are most readily found south of **Broad Street**.

Let us not ignore the window shutters! The oldest, most historic shutters still have iron, swiveling "shutter dogs," holding the shutters fast to the walls to prevent

46

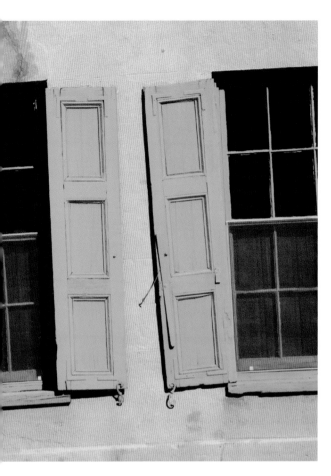

flapping about in strong winds. A telling photograph here would be just one corner of an old painted shutter with one of these authentic holders still on duty after so many years. Even shutters by themselves can tell a story well beyond their decorative appeal. They have served as armor against the ravages of hurricanes and war.

Another detail to photograph might be a single scroll in a wrought-iron gate. A delightful close-up composition can be of just one or two scrolls, combined with a piece of ivy or springtime blossom poking through or standing behind the iron. Here, you can contrast the strength of the iron with the fragility and transience of the gentle flower, all telling of the muscular craftsman-ship of yesteryear's blacksmiths.

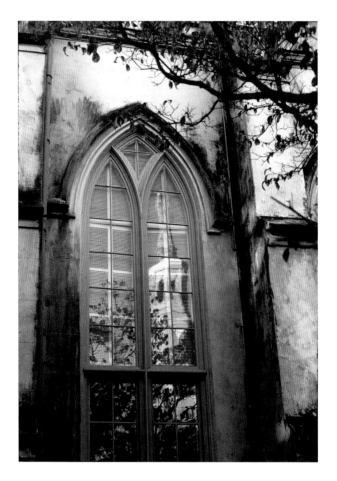

Window Views & Reflections

Charleston's windows offer an array of creative opportunities. Many still contain cold rolled glass, an early way of fabricating glass that leaves architecturally interesting waves and irregularities. First, scrutinize window exteriors for storytelling reflections. One example, viewed here, shows the windows at the **French Huguenot Church**. Note how the glass reflects **St. Philip's Church**. As you become more aware, similar views will appear elsewhere.

[IN FOCUS] ————————————————

Reflections

Reflections can add interest to your compositions. Try using mirrors, harbor and lake waters, puddles, windowpanes, even doorknobs. Just watch out for the spots of glare.

Interior windows, too, are well worth a second look. They may be the simple panes and mullions of a standard six-over-six sash in an old house or the aged glass of an historic church. Through these windows, find antiquated cemeteries, a profusion of azaleas, dogwoods or cherry laurel, an historic home or a lone bench. Some pew boxes next to sanctuary windows may be illuminated just enough to become a photographic asset, adding greatly to composition. Sometimes, a stairway to the church's balcony will lead to additional, elevated window views. Use a spot meter specifically on the scene outside the window to avoid overexposure. And avoid using flash or you will catch that unwanted "hot spot" on the glass.

Some buildings with captivating views include the **First Baptist Church** (1819-1822), **City Hall** (1800-1804), the **Old Exchange & Customs House** (1767-1771) and **Pink House**, as well as the **French Huguenot Church, St. Philip's Church, St. Michael's Church** and **St. Matthew's Lutheran Church.**

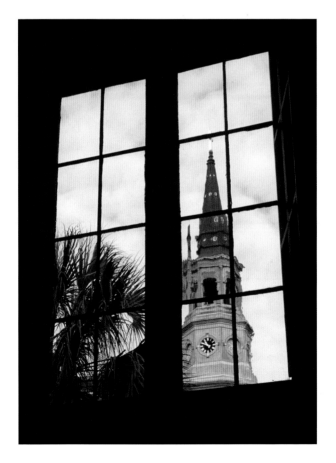

3 The African-American Experience

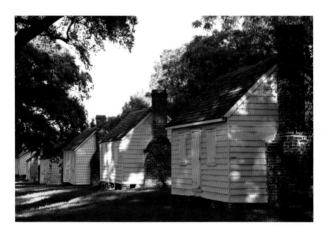

Slave History

Frequently, I'm asked about where and how to capture Charleston's African-American history. While it may not be immediately apparent as you wander the city's historic district, powerful elements of African-American history can be found and captured on film. Indeed, this history should be photographed to fully understand and authentically present Charleston's complete story.

Slaves were bought and sold in Charleston in great numbers. Sullivan's Island could be considered the African-Amercian "Ellis Island." Once brought into the city, slaves were auctioned at the **Old Exchange and Customs House**. Stand on cobblestoned **Gillon Street** on the north side of this building; before you is where the slaves stood, and above, through the now-enclosed arches of the Exchange, is where the buyers looked down, making their bids. Image options are limited, but whatever you capture will suggest this important story.

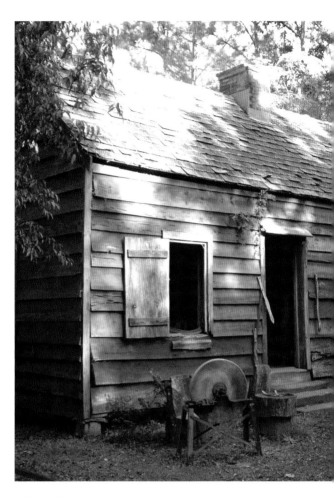

Aiken-Rhett House is a mansion museum, with slave quarters at the rear of the house, inside high walls. It is located at **48 Elizabeth Street**, just two blocks east of the **Visitors' Center** on **Meeting Street**. The slave quarters in the rear courtyard of the mansion can be photographed but not the interiors.

Heywood Washington House at **87 Church Street** features a restored kitchen and laundry rooms at the rear of the house, showing where slaves worked. Any professional use of photographs made at this location requires prior written permission. These limitations are based on security issues, as the collections housed in these museums are literally priceless.

McLeod Plantation on James Island has a remarkable number of intact slave cabins, some of the oldest wooden slave quarters in the South. The plantation, which today includes 40 acres, is located across the **Ashley River** three miles from

downtown, near the intersection of **Folly Road** and **Maybank Highway**. Owned by the American College of the Building Arts, public access to the plantation is limited; nevertheless, the slave cabins are visible from **Folly Road**, strung in a row under an avenue of huge oak trees. You can park across the street, walk across **Folly Road** (be cautious of the heavy traffic), and photograph this setting from the sidewalk.

Boone Hall Plantation houses a collection of authentic brick slave quarters. Boone Hall is located in Mt. Pleasant, just off **U.S. Highway 17** north. The slave dwellings sit aside one of the most beautiful avenues of oaks in the world. Early in the morning, streams of light edge the trunks of these grand oaks, highlighting the Spanish moss above. At the slave quarters, consider photographing from inside the cabins, looking out to the other cabins, capturing the raw architectural features and textured brick.

Rice Fields

Photography of African-American history would not be complete without recording the remnants of plantation rice fields. Rice cultivation was fundamental to Lowcountry plantation life starting in the 1700s, and it would have been impossible without the engineering skills, knowledge and labor of slaves. Slaves from western Africa brought with them experience in rice cultivation. The resulting rice fields can be found throughout the Lowcountry.

One easily accessible location is the **Caw Caw Interpretive Center**, south of Charleston on **Highway 17**. There, you can view old rice fields, dikes and gates ("trunks"), which regulated the flow of water in and out of the fields. Find a vantage point where you can capture in one frame a gate and/or wild rice stalks in the foreground with a rice field in

the background. You'll need much depth of field to keep it all in focus.

Further south on **Highway 17** is the **ACE Basin**, filled with old rice fields, now plantation hunting reserves. This area includes the inland coastal mashes surrounding the **Ashepoo**, **Combahee** and **Edisto Rivers**, considered the largest undisturbed coastal marsh in the States. They are flat, wide and teaming with wildlife. The best views can be found from the many back roads south of **Highway 17**, e.g. **Bears Bluff Road**. At dawn and dusk, the views are especially rich and colorful. I've caught them with sunsets and full moons, and I invite you to do the same.

Depth of Field –
Making the Foreground Soft and the Background Sharp

If you want the azaleas in soft focus and the houses to be sharp, focus on the houses and shoot with a relatively large, open aperture (e.g. f-4 or lower). On the other hand, if you want the azaleas as sharp as the houses, then use a smaller aperture (f-16 or up) for greater depth of field. Try shooting it both ways and compare the results later. In either case, set your aperture first, then adjust the speed of the shutter to accommodate the aperture setting. Use the tripod to steady the camera at speeds slower than 1/60 of a second. And if you have a "depth of field" preview function, use it before shooting to preview the difference in how the blossoms appear.

Another location, and it's a day trip for nature lovers, is on the east branch of the **Cooper River**. Rent a kayak or canoe, put in at the **Huger Public Park** up **Highway 41**, and paddle down the river. You will find plenty of old rice fields and the aged pilings from earlier docks. The river itself, brackish water producing mirror-like reflections, will leave you wondering which is top and which is bottom in your final photographs. The earlier in the morning you can make the trip, the better.

Sample photographs of old rice fields can be found in my book *The Plantations of St. Bartholomew's Parish*.

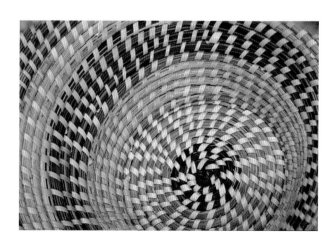

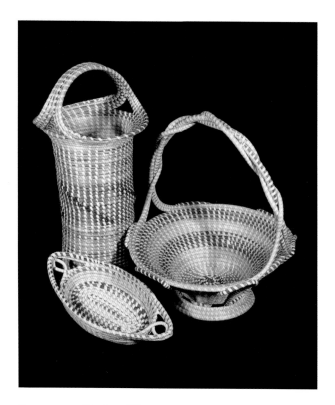

Sweetgrass Basket Weavers

The African-American sweetgrass basket makers of the Lowcountry maintain a cultural tradition that hearkens back to their makers' pre-slavery roots in Sierra Leone. It remains a unique art form, passed down through the generations, practiced exclusively along the American southeastern coast. Sweetgrass baskets and the women who make them have become almost an iconic symbol of Charleston. You'll find the ladies selling their sweetgrass baskets at **Meeting** and **Broad** streets, in the **City Market**, and at roadside stands along **Highway 17** north (leaving Mt. Pleasant). But the right approach is essential. Many of these African-American basket makers are reluctant to have their photographs taken, unless you make a purchase first and kindly ask permission. If you do neither, you're likely to receive a scowl, even a hand or towel raised to cover their faces. These ladies are dedicated artists, and they deserve to be respected.

"The most important thing is not clicking the shutter... it is clicking with the subject."
– Alfred Eisenstaedt

Try to choose a basket maker wearing colorful attire. Ask her to sew on a fairly large basket, so it shows up well in your photograph. Notice how skillfully she sews the sweetgrass, pine straw and bulrush with strips of palmetto fronds into colorful tones, patterns and shapes. If you do a portrait shot, shoot with the aperture a bit more open than what your meter tells you. Remember, darker skinned faces are always one-stop darker than lighter skinned faces. If, as an example, your meter says f8, then shoot at f5.6, unless you are using some fill flash. Do some close-ups of her hands sewing and some extreme close-ups of the patterns in the baskets. If you are shooting on **Meeting Street** at the **Court House**, you may find my friend Blanche Watts weaving away. Tell her I sent you.

Unfortunately, weavers are finding it increasingly difficult to obtain the sweetgrass they need from local marshes: residential and resort development is encroaching on the terrain where they obtain their supply.

Some of the basket ladies at these locations are also Charleston's "flower ladies," selling fresh flowers in the springtime. Between Thanksgiving and Christmas, they sell holiday wreaths. Some are made with sweetgrass; others are made of holly or bittersweet vine. You'll find these wreaths hanging along the fences on **Meeting Street**. Use the same, respectful approach. Buy something, and as you prepare to depart, be sure to express your appreciation.

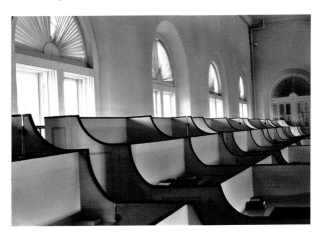

Worship & Education

Photographs can help to tell the story of slaves' worship experience in Charleston. One way is to photograph the balcony pews in many of Charleston's churches, where slaves

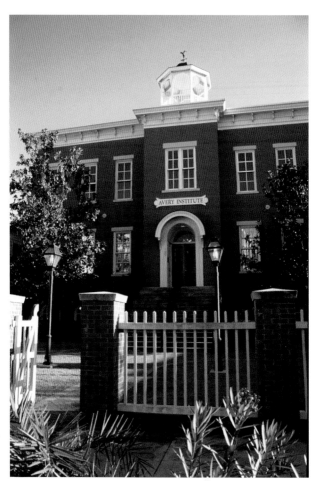

of the church's white parishioners worshipped. If an historic church is open for visitation, find your way up to the old balcony seating areas, look for interesting angles, and use a bit of creative imagination to depict the meaning of the setting. A wide-angle lens will help to capture these balcony pews and the main floor of the sanctuary. A bit of fill flash will highlight the pews themselves.

A number of churches have always been exclusively African-American, and you may want to include shots of them in your collection. One church that stands tall in black history is **Emanuel African Methodist Episcopal Church** at **110 Calhoun Street**. It is the oldest A.M.E. congregation in the South and has a rich history, including a role in the notorious but aborted Denmark Vesey slave

"Photography is a major force in explaining man to man."
– Edward Steichen

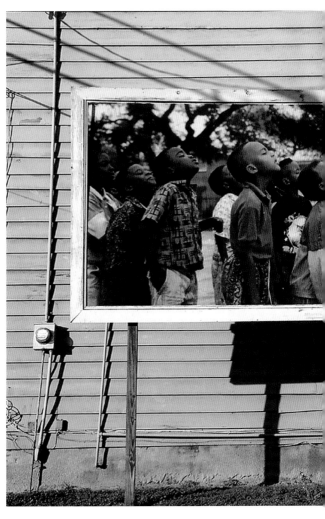

uprising. A memorial to that event is enclosed in the ground floor entryway, along **Calhoun Street**. Also, the **Morris Brown A.M.E. Church** (ca. 1875) at **13 Morris Street** and the **Central Baptist Church** (1891) at **26 Radcliffe Street** played important local roles in the Civil Rights movement. Both have colorful interior wall murals that are well worth photographing. Just check with the church offices for entry.

The **Avery Institute** at **125 Bull Street** is also important to African-American experience in Charleston. This beautifully restored brick school house, erected soon after emancipation in 1867, is the former Avery Normal Institute, Charleston's first free secondary school for African Americans. Now it is part of the **College of Charleston** and a research center for African-American history and culture. Open to the public, it features a large library and exhibits pertaining to Charleston

black history. The exterior of this handsome building poses well for an architectural photograph, as does the unusual sky-lit room on the top floor.

The "East Side Story"

The east side of Charleston offers unique photo opportunities. Here, as with similar and surrounding neighborhoods, the residents are primarily African-American in a part of town much less affluent than the rest. Its streets come as close to the feel of the 1920s and 30s, as depicted in the famed drawings of Elizabeth O'Neil Verner or scenes from *Porgy and Bess*. Its character is rich and varied, with some houses brightly colored and others uninhabited and about to tumble down. The neighborhoods have small churches, old cemeteries, fish take-outs and sweet shops, barber shops, freedmen's houses, small parks and playgrounds. You'll en-

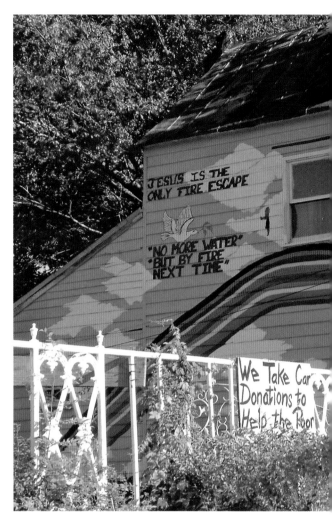

counter old timers, children at play, groups of men chatting. You may even run into Philip Simmons, Charleston's legendary master blacksmith – now in his 90s – and get invited into his still-active workshop off **Blake Street**. Daytime visitors often are welcome, if he's about.

This district is roughly bounded by **Meeting Street** on the west, **East Bay** to the east and **Mary Street** on the south. My favorite streets are **Nassau**, **Columbus** and **America**. I've photographed this area many times, as have photojournalist friends of mine, and we have always found the residents to be open. The resulting photographs, be they old doors, small shops or environmental portraits, show the expressive life in these neighborhoods.

Go to the intersection of **Reid** and **America** streets, and
you'll come upon two intriguing finds: on one corner is a
slightly-less-than-life-size replica of a Charleston single house,
skinny and tall, remaining from one of the Spoleto Festival's
"site-specific" avant-garde art projects. And diagonally across
the street is a mini-park, featuring a billboard of young black
children looking upward toward an actual flagpole with an
African-American version of the American flag in colors of
red, green and black. This too was a "site-specific" art installa-
tion and is best photographed in the morning.

Another site, a few blocks away next to **St. Luke's Reformed
Episcopal Church** at **60 Nassau Street**, is a one-of-a-kind
"sculpture" garden with upside-down blue bottles posted
atop an oyster structure entitled, "Rice, River and Rattle-
snakes." It's a must!

4

Making the Extra Effort

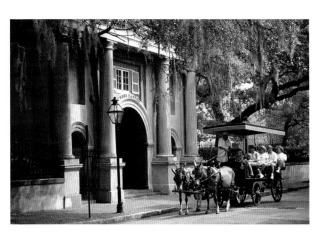

Horse-Drawn Carriages

Photographing the horse-drawn carriages of Charleston would seem an easy task, as plentiful as they are. But once into it, you learn just how tricky it can be. Why? Well, things get in the way… and things happen. The carriages are in motion, vehicles pass by and block your view, cars and trucks are parked everywhere in the background – and the horses, well, horses will be horses!

So, what to do? I recommend seeking a location where the distracting, parked cars are absent in front of an interesting, historic piece of architecture. Wait for a carriage to pass by on one of the regular carriage routes. But be prepared in advance for the passing of the carriage, for it happens fast. Set your metering from the nearby architecture. Set your focus on a spot on the road over which the carriage will pass. Next, set your camera speed to 125th of a second or higher,

> "If the photographer is not a discoverer, he is not an artist."
> –Paul Strand

to avoid blur in your photo. (Remember, it's an object in motion.) Now you're set for shooting

Many carriages come from **Broad Street** and drive along **East Bay Street** (which becomes **East Battery**). Along this stretch, one can catch the carriages in front of **Rainbow Row** and the antebellum homes. Now and then, drivers will pull over into no-parking zones to allow vehicular traffic to pass or to talk about a particular location. For a few moments, you have an opportunity for compositions without cars and without carriage motion. Mornings are best for superior lighting.

A truly Southern scene is when the carriages stop under a huge oak tree in front of the **Calhoun Mansion** (1876) at **16 Meeting Street**. It is the largest home in the city, with 24,000 square feet. This popular house museum, open only periodically, has been used in film and television sagas. And you can rest assured that carriages always stop there under the oak tree and directly in front of the mansion, making a charming, photogenic scene in the afternoon light.

If you want the white steeple of **St. Michael's** in the background of your carriage picture, hang out on the northeast corner of **Broad** and **Church** streets. Carriages will come toward you from the lower part of **Church Street** and cross **Broad Street**. When the carriage is in the center of **Broad Street**, the steeple will be directly above and behind the scene. Be prepared, and shoot fast. Mornings are best for the lighting on the steeple and the carriage.

These same carriages then proceed along **Church Street**, toward the **Dock Street Theater** and **St. Philip's Church**. Morning is the best time to capture a carriage in front of the theater; afternoon is the time for **St. Philip's**. At the church, using a wide-angle lens from the right spot, you can include most of the steeple in your composition.

If you want grand, old-South white columns, a good location is in front of the **South Carolina Society Hall** at **72 Meeting Street**, just south of **St. Michael's Church**. Generally, drivers halt their horses at this spot to give a short history on the society. In the afternoon, it's a classic view.

"To me, pictures are like blintzes – ya gotta get 'em while they're hot."

–Weegee

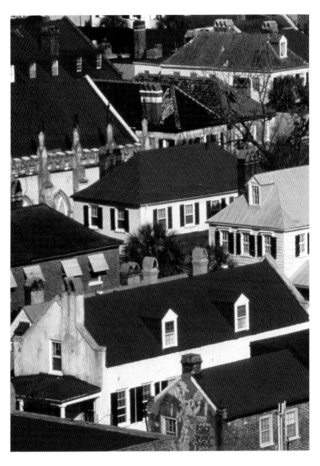

City Views from Above

Photographers, arise! Let's get above it all and view the city's historic rooftops, steeples and significant buildings from elevated locations. This takes a little effort, but is well worth it. You can start by climbing the stairways (or taking the elevators) in the parking garages amply scattered about town. With persistence, you might obtain special permission to climb up inside the historic steeples at **St. Michael's** or **St. Philip's Churches**. The steeple option may take some negotiation, but it definitely yields the most exciting results, and you just might pull it off. If not, shooting from a few city parking garages or restaurants with elevated views works well.

Views of **Marion Square** can be obtained from the **Francis Marion Hotel** at **King** and **Calhoun** streets, if you have a room, or from the **City Parking Garage** just adjacent on **King Street**. The scene will include **Citadel Square Baptist Church**, **Emanuel AME Church** and the **Old Citadel**

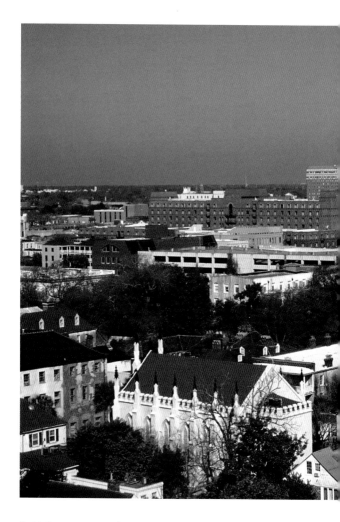

(1822), now an **Embassy Suites Hotel**. I love this view in the very late afternoon, an hour or two before sunset, when the light is soft and warm.

The **City Parking Garage** on **Cumberland Street**, between **Meeting** and **Church** streets, lends a great view of **St. Philip's Church**, the **U.S. Customs House** (1849-1879), the **Charleston Harbor**, and **Circular Congregational Church** (1892), with its historic cemetery. Afternoons give the best lighting for most of the subject matter. Better yet, if you are an early riser and are thrilled by shooting colorful sunrises, this is the place to do it. Some mornings, reds spread like paint across the sky behind the steeple of **St. Philip's Church**. Remember, the best colors appear about 40 minutes before the sun edges over the horizon. So rise early. You just might meet me up there.

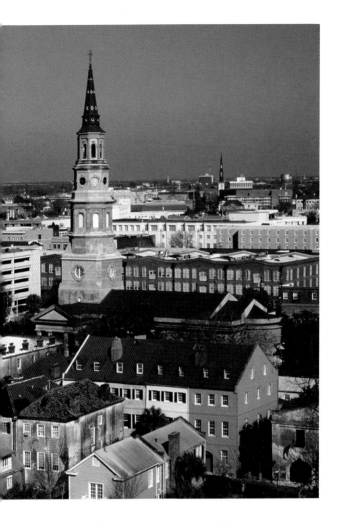

The **County Parking Garage** at **King** and **Queen** streets gives close views of the steeples of the **Unitarian** and **St. John's Lutheran** churches to the west and **St. Michael's Church** to the east, both with plenty of rooftops. Study the moonrise schedule and, with weather permitting, this vantage point is great for catching the moon right next to the clock on that gorgeous white steeple.

Parking garages, parking garages, parking garages! There are plenty around, more than I have mentioned here, and each has its own view. I leave the hunt, adventure and discovery to you as you seek those wide photographic vistas!

"You don't take a photograph, you make it."
 – Ansel Adams

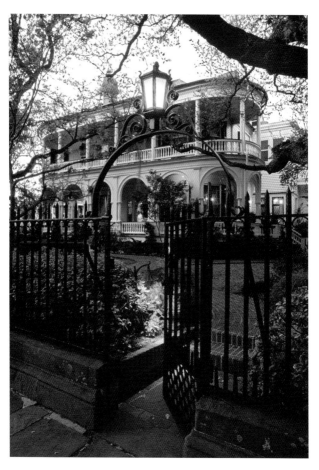

Charleston at Dusk & Night

Late evening and night photography is more than worth the effort in Charleston. At these times, you can capture an ambience of the city that is totally different from daytime. Don't worry about having fast film if shooting with a film camera. A tripod will handle all situations well. If using a digital camera, simply go into your menu and select a "white balance" (WB) suitable to the kind of light you are working with.

One of the most appreciated night scenes in town is on **Church Street**, featuring the **Dock Street Theater** with **St. Philip's Church**, as you look north from **Chalmers Street**. Find ways of including the lit "**Dock Street Theater**" sign in some of your compositions. And, if your exposures are extended beyond just a few seconds, to 20 or 30 seconds, you will capture those streaming red lines from the tail lights of passing cars. To accomplish this with the camera, set the aperture high (e.g. f 16) and you'll obtain the extra time needed for a long exposure. Watch over your shoulder, and, when you see a car

approaching from behind, prepare to start the exposure the very second it passes by.

Another classic night shot is the steeple of **St. Michael's Church**. Make it interesting by including a gas lamp in the foreground. This steeple is not always lit brightly, so you need to be lucky. For a long exposure, use a tripod and a high aperture setting. If this steeple is not well lit, go down **Meeting Street** and work with the steeple of **St. Philip's**. This steeple is well lit throughout the year.

While on **Meeting Street**, check out the lighting on the front of **Hibernian Hall**, with its huge gas lamps. Try the close-up angles, looking up at the columns.

Another fun night view is looking across **Colonial Lake**, featuring the houses along **Rutledge Avenue** and, perhaps, a full moon. Position yourself on **Ashley Avenue** on the western side of the lake, looking east.

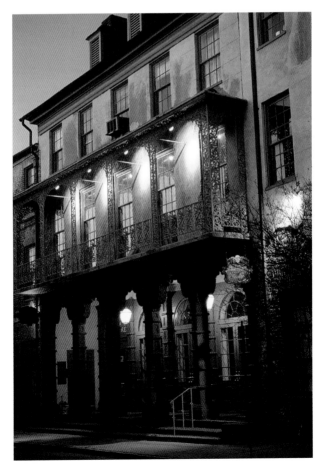

Night photography requires a little extra preparation and equipment. First, a tripod is a must. Any speed film will work if you use a tripod. You don't have to use 400 ISO. Its only advantage is shortening exposure time if you're holding the camera in your hands. Second, carry a pen flashlight. It comes in handy when checking your camera settings in the dark (unless you are using digital, in which case the LCD screen suffices). Third, a shutter-release cable is helpful, but the same thing can be accomplished with the shutter-release delay switch.

When focusing in the dark, find a lit object in your scene and move your camera about to focus on the lit object, then re-position the camera for the composition. If you have auto-focus, then there's no problem. For measuring light, the easiest thing to do is to use the camera's automatic setting (if it has one), count the seconds of your exposure, and then re-shoot at more and fewer seconds.

As an example, if your camera exposes for 10 seconds, then try it at 5 seconds and then 20 seconds. All the while, you are keeping your lens aperture setting constant as required for the right depth of field. So you see, you are adjusting the speed of the shutter, not the lens aperture opening. If your camera does not have an automatic feature, then try this for starters: using ISO 100 film and shooting at night on the street, start with a ½ second exposure, then 1 second, then 2 seconds, like that, with an f5.6 aperture. If you want to train yourself, do a few test shots, write down your settings for each exposure, get the film processed the next day, evaluate the results and then return the next night to re-shoot. If you're working with a digital camera, you can view your results immediately.

[IN FOCUS]

Selective Focus

Selective focus is an excellent way to isolate your subject from confusing surroundings. Selective focus means you focus sharply on one object while rendering the rest of the image soft or blurred. An image with select focus takes the eye directly to that special object. To achieve this effect, use low f-stops (f2 or f2.8). This technique is frequently used when photographing flower blossoms amid leaves or wrought iron designs with buildings in the background.

City Columns, Plantation Oaks

Repetitions. When you find them in architecture or nature, they present the opportunity for compelling compositions. Repetitions may be just one element among others in your compositions, or they may be the sole feature. However you feature them, using repetitions is aesthetically pleasing.

Columns, cornices and pedestals abound in Charleston, and they can be lined up into receding patterns. I find that shadowing from early morning or late afternoon light, especially on columns, helps set each structure apart from the next. If the repeating objects are relatively near to your camera, a normal lens will be sufficient. If they are at some distance from your camera, a telephoto lens works better, pulling the repetitions closer together into a tight single frame. For the latter, a tripod helps steady the camera. Remember, the longer the lens, the more sensitive it is to vibrations. Hand-holding a camera works only up to a point. For sharpness

throughout the image, focus on an object about one third of the way into the picture. If you want a softer focus on the distant objects, then focus on the nearest object.

One excellent site to photograph is the remains of the old **Charleston Museum** at the corner of **Calhoun** and **Rutledge** near the Medical University of South Carolina. Originally built as a venue for the Confederate Veteran's reunion in the late 1800s, it became the site of the **Charleston Museum** shortly after. The museum caught fire and burned in the 1960s, leaving stone stairs and massive columns. What remains is intriguing, almost like a theatrical stage set.

Avenues of oaks, found mainly at plantations, offer another opportunity for compositions with repeated elements. A telephoto lens, aimed down a row of these massive tree trunks, creates strong and impressive pictures, especially with Spanish moss in the frame. Catching these avenues

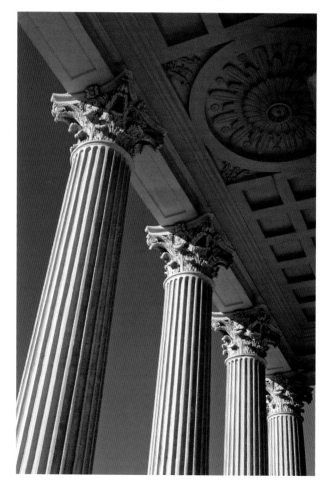

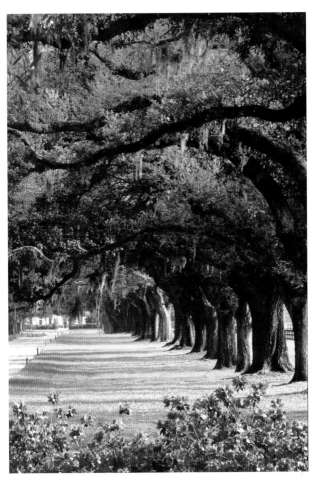

early or late in the day will provide wonderfully dramatic, warm lighting from the sides. Even more dramatic, at the same time of the day and if the sun is coming toward you, the hanging moss may be backlit, yielding moss with striking silver edging. Use your tripod, take time in composing and enjoy the aesthetic thrill of it all.

Seasonal Subject Matter

Springtime & Blossoms

Charleston strikes its most photogenic pose in springtime, when flowers of all varieties are in full bloom, gracing the streets, public parks and private gardens. In spring, you'll have a photographic "heyday," or more suitably, a "flower day," with innumerable creative possibilities.

Spring in Charleston is a great show of psychedelic azalea, white dogwood, redbud and blue wisteria. Some of this splendid show is in private gardens, but don't despair. Every spring, the Historic Charleston Foundation sponsors a house and garden tour that gives entrance to some of the most beautiful gardens in the world.

The abundance of publicly accessible gardens also invites compositions that combine architecture with the season's blossoms. One location is the churchyard at **St. Philip's Church** – the one across from the church, on the west side

of **Church Street**. It will be filled with azaleas, dogwoods and hanging moss.

Another remarkably lush location is the **Unitarian Church** cemetery on **Archdale Street**. The springtime foliage here is abundant and delightfully "un-manicured," giving the setting a romantic old South feeling. The church's neo-gothic tower (1780-1854) in the background adds to this compositional recipe.

"Whether he is an artist or not, the photographer is a joyous sensualist, for the simple reason that the eye traffics in feelings, not in thoughts."
– Walker Evans

For lush blue wisteria, shoot the vines covering the fencing at **54 Meeting Street** (1800-1806) in the afternoon for best lighting. The **Edmondston-Alston House** (1825-1838) at **21 East Battery** features a wisteria vine that winds around the mansion's grand gate lamp. Morning is the best time to capture this picture.

For tulips, visit the rear of the garden at the **Nathaniel Russell House** (1808) at **51 Meeting Street**. They appear best early in the morning, just after the gate opens, and are especially delightful when the blossoms, heavy with morning dew, are back-lit. The formal garden (composed of heirloom plants appropriate to the period of the house) is fabulous for photography from almost any vantage point.

Ornamental peach blossoms of the peppermint variety grace the wrought-iron fencing every spring at **Washington Park** on **Meeting Street**, behind **City Hall**. I love framing these blossoms with the designs of the fence, using the columns of the **South Carolina Historical Society** as background.

If you are shooting in the winter months, you will find camellias in great abundance throughout Charleston. For one scene depictive of Charleston, try **Washington Park** on the **Broad Street** side. Here, the camellias can be used to frame the steeple of **St. Michael's** across the street.

When it comes to flowers, your point of view will range from ultra-tight "mystical" close-ups to wide-angle vistas of whole gardens in full bloom. But for photographing Charleston in bloom, try to achieve compositions that include columns, steeples, gates, fences, porticos and fountains for that distinctive "sense of place."

[IN FOCUS]

Cropping

Cropping your image, when seen through the viewfinder, means cutting out or eliminating what is unnecessary or distracting before you take the shot. This "junk" may be at the top, bottom or sides of your image. Keep the image relatively tight. Cropping is more easily done in the viewfinder than later when processing or printing the picture.

The Gold of Autumn

Charleston's autumns are usually more subdued and subtle than found inland or up in the mountains. And, unlike New England where the maples turn a rich spectrum of reds, Charleston's fall colors are warmer, softer and glow much longer in the year; golden leaves here can last well into December. The most spectacular trees in the autumn are the huge ginkgo trees found here and there in the old city. Their large leaves turn from green to yellow, and then to gold, giving irresistible subject matter for the camera.

One wonderful setting for these ginkgo golds is in front of the **Charleston Library Society** (1914) at **164 King Street**. The gold leaves hanging next to the silver strands of Spanish moss make for wonderful photographs. And, once fallen, these ginkgo leaves can blanket a lawn; they will call out to you in the early afternoon sun.

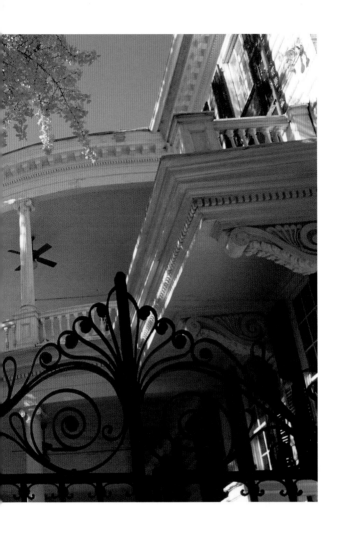

At **15 Meeting Street** (1770), the ginkgos arch around the circular, white portico, all behind an ornate, black wrought-iron gate. This scene is shot best with morning light.

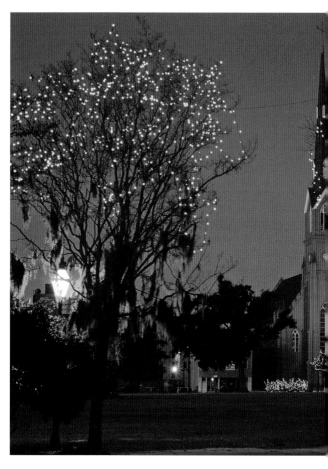

Holiday Lights

Charleston's **Marion Square** and **Broad Street** are the most delightful scenes for nighttime photography during the holiday season. **Marion Square** features thousands of white lights adorning palmettos and holiday figures, with lit church steeples towering above. Compositional opportunities are ample, and, with fountains and steeples included, you capture the essence of Charleston at Christmas.

Colonial Lake offers an elegant scene of a single, lighted, floating Christmas tree, with lights and historical houses reflecting in the water.

On **Broad Street**, the palmetto trees are strung with white lights (in lieu of snow) and gas lamps are decorated with greenery and ribbons. Again, with your night photography skills, you can compose views of either **St. Michael's** white steeple or the top of the **Old Exchange Building**, both topping the street's row of white holiday lights.

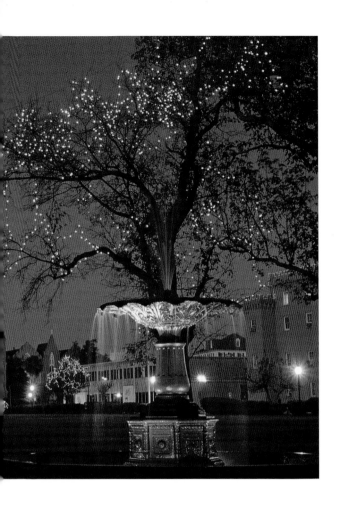

Christmas decorations on the homes of Charleston, depending on where you are viewing, range from "natural" and subtle to the brightly colored and entertaining. In the historic district, mainly south of **Calhoun Street**, the front doors of homes and some churches display attractive wreaths of natural foliage or clusters of fruit. The gates at **St. Michael's Church** display the latter. These wreaths are great for close-up photos. Nighttime offers views of Christmas trees shining through windows, giving that heart-warming, old world look. Quite different, however, are the residential neighborhoods north of the **Highway 17 Crosstown**. Here, in mainly African-American neighborhoods, homes and yards at night display all colors of the rainbow, surrounding all manner of delightful character scenes – mangers, angels, Disney characters, Santa Claus and his reindeer. A drive northward up King Street will give you a taste. Stop, enjoy and capture a few more photographs.

The grandest display of holiday lights can be found at the annual Festival of Lights at the **James Island County Park**. It's a drive-through fantasia where dozens of Charleston and Lowcountry scenes are fantastically depicted throughout this park with millions of holiday lights. Some scenes are reflected in the park's ponds; some are in motion; some you can walk into, pathways of delight.

The first Saturday in December offers the annual Parade of Boats in **Charleston Harbor**, featuring shrimp boats, yachts and other vessels all decorated with holiday lights. The regalia of lighted boats parade from the Cooper River bridge around the **Battery** to the **City Marina**. Be prepared with fast color film, or a high ASA setting in digital cameras, and a tripod.

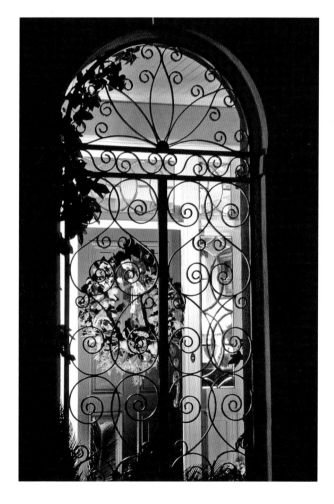

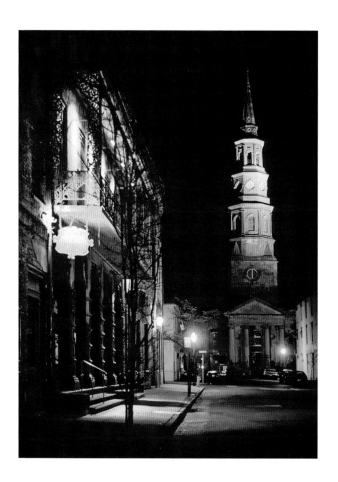

[IN FOCUS]

Shooting Streetscapes at Night

In the dark of night, faster films are best, e.g. ISO 400. In digital cameras, find and use the 800 or 1600 "film" speeds in the set-up menu. A tripod is always preferable; otherwise, steady the camera on or against some object. Adjust your shutter speed last. Bracket your exposures to ensure at least one shot is "right on." Long red streaks from the tail lights of passing cars can be captured with very slow exposures, e.g. 10 seconds or more.

6

The Holy City

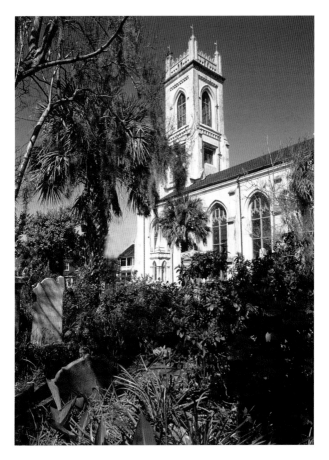

Church Exteriors

Known as the "The Holy City," Charleston is home to one of the most diverse assortments of religious structures in America, originating as far back as the late 1600s. Along with the earliest Anglicans came the dissenters (Presbyterians, Congregationalists and Quakers), French Huguenots, Anti-Baptists (Baptist), Jews, and, later, Roman

Catholics, Lutherans and Methodists. As a thriving port city, Charleston became a major center of religious tolerance. Carolina's original constitution, written by John Locke, provided for religious freedom and served as a basis for the freedoms embodied in the U.S. Constitution. Today, the city is not highly ecumenical, but it is denominationally rich and varied.

I offer this brief history in order to give you a greater appreciation of what otherwise may seem only a large number of church structures. Knowing why the streets are lined with so many churches may bring more interest, even passion, into your photography of historic church architecture.

Photographing the exteriors of these historic churches is as engaging as it is challenging. The churches are tall and the streets narrow, making it hard to back up enough to gain a full and impressive view. Then there are all those cars parked in your view. So what to do?

Lacking a large-view camera or a perspective-control lens, you simply have to accept those

> "The sun is but a bell ringing out light."
> – Leonhard Euler

converging, architectural lines when you aim upward, and use them creatively. It's commonly done – even by the pros. Use a wide-angle lens (18, 24 or 28mm) or zoom to your widest angle. Bend low and compose upward. If available, a lamppost, tree branch or wrought-iron gate can help to frame your composition, giving it more interest. If you want truer perspective (without those converging, vertical lines), walk a distance away and find a vantage point that works. Or, if you have a van or truck, stand on top of the vehicle to obtain a truer perspective. The higher you get in relation to the center of the structure, the more those converging lines straighten out. I used this technique repeatedly when creating photographs for *The Churches of Charleston and the Lowcountry*. The book is filled with images, histories and maps, and may serve you well as a guide.

Try elevating yourself even more by venturing to the top of a parking garage. As an example, **St. Philip's Church** on **Church Street** can be photographed from the top level of the **City Parking Garage** on **Cumberland Street**. It's a grand view of **Church Street** and **St. Philip's Church**. Zoom in to suit your preferred composition. Afternoons are definitely best.

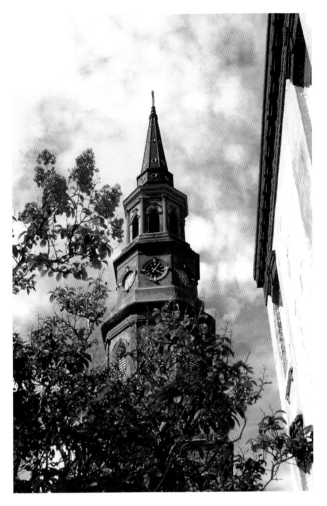

Traveling further out from Charleston, a daytrip will take you to a number of historic and wonderfully photogenic churches and chapels-of-ease. The latter is a term used in the 18th century to describe parish churches built far out in the countryside, away from the parish church, for the "ease" of early Anglican planter families for worshipping (and tithing!) nearer their plantations

[IN FOCUS]

Vertical Format

Don't get stuck in "horizontal hold." Every time you're about to make a picture, ask yourself how it would look as a vertical. Scenery often looks best in horizontals, but any subject taller than it is wide may call for a vertical.

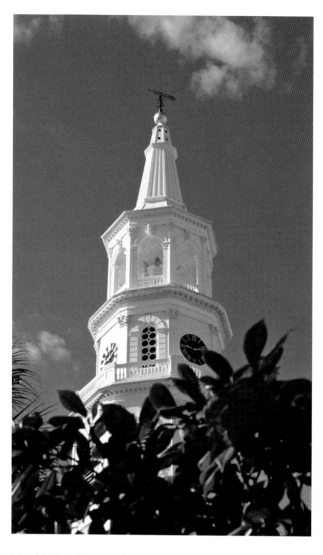

Notable for photography are the quaint **Grace Episcopal Chapel** in Rockville, a waterside village at the end of the road on Wadmalaw Island; **Old St. Andrew's Episcopal Church** on **Highway 61**, surrounded by lush azaleas in the springtime; **St. James-Goose Creek Episcopal Church** near Goose Creek, the oldest parish church in the Lowcountry; **Christ Episcopal Church** in Mt. Pleasant, north on **Highway 17**; and **St. Thomas** and **St. Dennis Church** farther north of Mt. Pleasant and north of the village of Wando (Cainhoy) and its aged cemetery.

Farther north yet, in the fishing village of McClellanville, are the Episcopal churches of **St. James-Santee**. The original church is a bit of a drive through the woods and over a

dirt road, northeast of McClellanville, off **Highway 17**. Its colonial interior, with wooden pews and pulpit, stand in sharp contrast to a modern camera. Open the doors, if you can gain access, to let the light illuminate the otherwise dark interior. Use natural light, rather than a flash, to experience it as it would have been to parishioners in its time.

The more recent 19th-century chapel in McClellanville, a winsome carpenter gothic structure with cypress shingles, offers an array of surprises, inside and out, which you will discover. Plan to photograph this church in the morning for its exterior and in the afternoon for illumination on its stained glass windows. Both churches are often unlocked for easy entry. These two churches are more than worth the half-day trip it takes to view them.

Steeples by Day & Night

The steeples of Charleston pierce the sky in all directions, variably evocative of a European village and an urban cityscape. Look from **Patriot's Point** in Mt. Pleasant or the new **James Island Connector** bridge (**SC Highway 30**). The views are exquisite. The steeples are harder to view from downtown Charleston itself, where parking garages, office buildings, condominiums, college dormitories and medical complexes have altered the streetscape, making the city more dense. Nevertheless, there are ways to be creative in photo-graphing these spires and capturing their special charm.

Let's take, for example, **St. Michael's Church** at **Broad** and **Meeting Streets**. The early morning and late evening light-ing often warms up the stark white features of the steeple with gold and pink tones. So rise early or delay your evening dinner to get the best shots. In the mornings, a great vantage point is from **St. Michael's Alley**, just south of the church, or from **Broad Street** in front of **City Hall**. Use a tripod and zoom in on the details of the steeple bathed in these soft colors. In the evening and just before sunset, position your-self in front of **Hibernian Hall** on **Meeting Street**. There, you can catch the glow of color on the steeple, framed with wrought-iron fencing and the large gas lamp in front.

"In order to 'give meaning to the world,' one has to feel involved in what he frames through the view finder."
– Henri Cartier-Bresson

Then there are the "moonrise and steeple" compositions so abundant around the time of the full or crescent moon. Again, with **St. Michael's** as an example, you can frame the steeple, the moon, and a gas post along Broad Street between **Meeting** and **King**. For another view, you can capture a moonrise next to **St. Philip's** steeple from the graveyard at **Circular Church** on **Meeting Street**. The scene can be haunting.

"We do not make photographs with our cameras. We make them with our minds, with our hearts, with our ideas."

– Arnold Newman

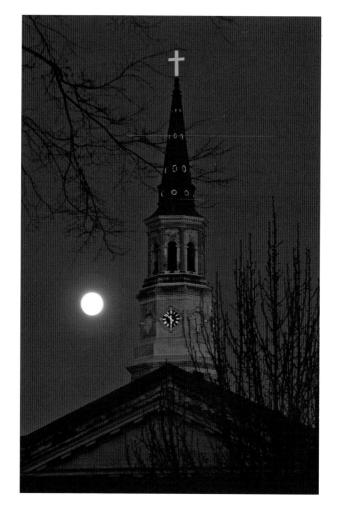

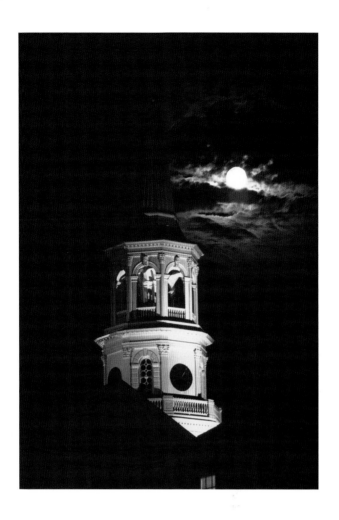

[IN FOCUS]

Metering Bright White Subjects

Subject matter that is intensely bright or white within your composition will fool your meter, daytime or night time, with that subject matter showing up in your final image as overexposed and washed out. An example would be the steeple of St. Michael's Church, brightly lit by strong sun or against a night sky. To overcome this problem, use the spot meter directly on that bright object before making the exposure or simply adjust the aperture setting downward, thereby letting in slightly less light.

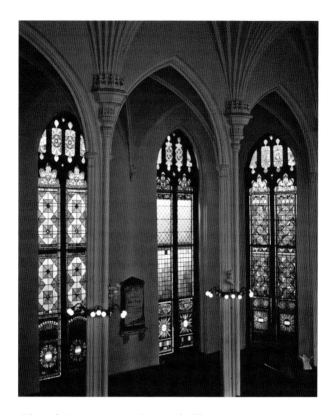

Church Interiors & Stained Glass

The interiors beckon. As overtly appealing as are the lofty exteriors of Charleston churches, entering them offers a whole new world of rich architecture and photographic opportunities. You will absorb the creativity of the architects and artisans who designed and built these edifices and created places intended to elevate the spirits of those who enter.

I offer a word about access to these churches' interiors. Only a very few are open daily to the general public, and that often depends on church volunteers keeping their schedules. I suggest that you arrive on a Sunday, participate in the service and/or undertake your photography in the hour afterward. Or check the church's website for information about visiting hours. For those with a particularly strong interest in exploring the inner reaches of a church, contact the church office in advance and make special arrangements.

Before you shoot inside these churches, I need to offer some advice about films and/or "white balance" in digital cameras. Remember, interior lighting has its own "color temperature;" it's not daylight. It follows, then, that if your camera is already loaded with daylight film, you need an 80A filter

or tungsten (T) to accommodate the tungsten lighting. My favorite is Kodak's Ectachrome 64T, a slide film. Negative films are also available for tungsten lighting. Digital cameras generally have a setting for tungsten lighting in their menus, labeled "WB." Once inside the sanctuaries, ask a sexton to turn on some lights. Don't be shy.

As you enter, do yourself a favor. Sit in one of the pews for a while and take it all in. Whatever suits you – prayer, meditation, reflection or silence – absorb the spirit of the place, appreciate the beauty of the architecture and its details, read the stories in the stained glass windows, and note the meaning of the religious symbols. Then, with an enhanced awareness for the setting, proceed with your photography.

Some churches' interiors are especially noteworthy.

The Unitarian Church, **4 Archdale Street**. Considered the oldest Unitarian church in the South, it was designed by Charleston architect Francis Lee in 1852. He recreated the previous structure into a beautifully gothic version with a ceiling of fanned arches. It offers one of the best collections of stained glass windows in Charleston. Use the balcony for the best angles. Sometimes, this church is opened by volunteers on Fridays and Saturdays, 10 a.m.–noon.

St. Michael's Episcopal Church, **Broad and Meeting Streets**. This is a classically Georgian church with an elevated pulpit and a Tiffany window facing Broad Street. Opposite that window, notice the possible compositions as you look through the east windows out into the cemetery. Expose specifically for the window to capture the presence of the cemetery outside and let the pews illuminate as they will. This church is open daily.

[IN FOCUS] ———————————————

Stained Glass Exposures

To photograph stained glass, use daylight film or the digital camera menu's daylight setting. Expose directly on the light of the window, excluding any of the church's interior. Indirect lighting on the outside of the window often gives more even illumination than direct sunlight, but not in all cases.

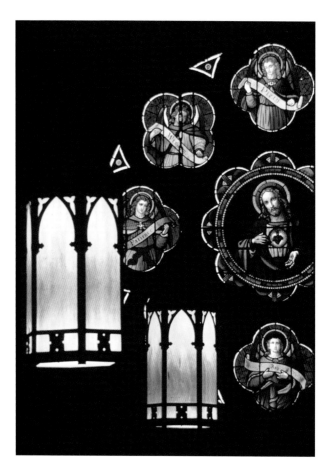

First Baptist Church, 61 Church Street. This is one of the city's best examples of Greek Revival architecture. Note the windows with etched glass, the hurricane lamps on their sills, and the old, wooden box pews in the foreground. Expose for the glass to avoid overexposure.

Circular Congregational Church, 150 Meeting Street. One of Charleston's rare examples of late 19th-century Romanesque Revival, it has curved wooden pews that fit into the overall circular architecture. Use the balcony to look down on the curved rhythms of these pews, zooming in for just one or two pews or zooming out for the entire collection. Remember that repetitions are a great feature to create interesting photography.

French Huguenot Church, Church and Queen Streets. Another gothic revival interior with especially wonderful woodwork and a magnificent chandelier hanging at the center.

[IN FOCUS] ————————————————

Photographing Church Interiors

1　When taking a picture from the church's balcony use a wide-angle lens to capture the view and reduce distortion.

2　Use your tripod; if you are without a tripod, steady the camera on a pew or railing.

3　Use the higher f-stops for greater depth of field (e.g. f-8 or above), unless you are using a wide-angle lens which gives good depth of field at lower f stops.

4　View the rear of the sanctuary from the altar; often, a huge and magnificent organ with decorative pipes sits atop the rear balcony.

5　Stand in the center aisle and capture the window light spilling down on the pews; compose these together, catching the rhythms of the windows and pews.

6　Know that cloudy or rainy days work well for photographing these interiors since the light coming through the windows is less intense and more in balance with the interior.

7　Finally, measure the light carefully with your camera's meter; the light from the windows, especially on bright days, will fool the meter, resulting in underexposures of the interior.

8　Photograph the windows whether stained glass with colorful patterns or holy symbols, depictions of religious history, or old imperfect glass revealing graveyard scenes outside. Doing so can be an aesthetic and spiritual treat.

9　Vary your compositions. Full window photographs are dramatic, but so are tight close-ups of window details. (The latter can serve as rich material for personal greeting cards.) Just set up your tripod and zoom in. Photograph a whole series of windows in one composition, best from an angle, and include some pews or columns in the foreground. For this, use a tripod, a wide angle lens and good depth of field so that the whole scene is sharp. Expose for either the windows or the pews for different effects.

Central Baptist Church, 26 Radcliffe Street. Designed
by one of Charleston's few 19th-century African-American
architects, this church features simpler gothic windows and
Italianate detailing. Look for the marvelous collection of
wall and ceiling murals done by an itinerant Native Ameri-
can artist of the early 20th century.

**Temple Beth Elohim, 90 Hasell Street, between King and
Meeting Streets**. This synagogue is another of the city's
Greek revival temples. Capture the mahogany ark and hand-
some window designs. Look to the rear and note the pipe
organ; the organ's presence is evocative of the developments
that characterize American Reform Judaism.

St. Mary's Roman Catholic Church, 95 Hasell Street. Op-
posite the synagogue and built in the classical revival style,
this church features colorful wall and ceiling murals, and
very vibrant stained glass windows.

Cathedral of St. John the Baptist, 120 Broad Street. The gorgeous, stately interior shows gothic arches with white marble and colorful stained glass. The view from the balcony is spectacular and offers an ideal perspective.

St. Matthew's German Lutheran Church, 405 King Street, across from **Marion Square**. Although this church was hit by a disastrous fire in 1965, the handsome marble altar and the German stained glass window in the apse survived intact. The tall windows along the sanctuary's south walls stand bright through most of the day, offering brilliant exposures. The church is often open for meditation and prayer during the week. For photography, check with the office first.

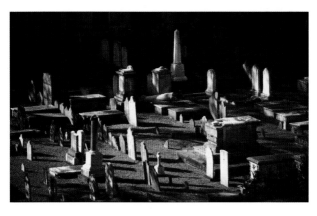

Old South Graveyards

Given their ancient live oak trees draped with hanging moss, the seasonal blossoms, the intricate wrought-iron fences and gates, and centuries of old tombstones, Charleston's cemeteries provide rich material for the creative photographer. Before shooting, walk the cemetery, read the names and dates, and take a moment to sense the passing of Charleston's generations.

Charleston abounds with old cemeteries, but a few provide exceptional scenes. The adjoining cemeteries at the **Unitarian Church** and **St. John's Lutheran Church** on **Archdale Street,** one block west of **King Street,** are my favorites. Each has its own special character. **The Unitarian cemetery** is known as "the garden of independent thought" and is Rousseau-like in its naturalness. In spring, the foliage is especially lush with a profusion of blossoms and hanging moss. By contrast, the **Lutheran cemetery** has a Germanic tidiness. Late in the afternoon, the sun casts strong shadows along the rows of old tombstones while illuminating the white steeple above.

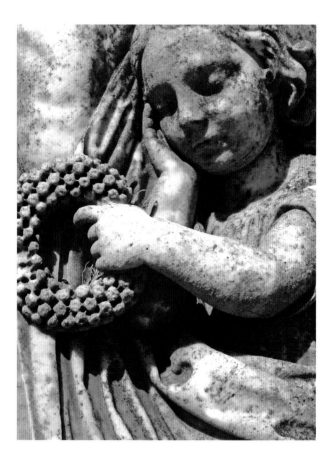

One picturesque entry to these cemeteries is down **Gateway Walk** with its entry point between **161** and **163 King Street**. Look for a huge wrought-iron gate between brick pillars and topped with an old lamp. It leads along a pathway to the cemeteries. While on it, note the lighting on its tunneled appearance, suggesting the metaphor we photographers always love – moving through darkness to light.

If you want really old, the **Circular Congregational Church** cemetery on **Meeting Street** dates from the early 1700s. The funerary art in this graveyard is among the oldest in the city. Some tombstones are carved with skull and cross bones, a motif popular with early colonial residents. Others feature the stylized weeping willow. To best capture these details photographically, the trick is to catch the sun at an angle oblique to the stones, thereby catching subtle shadows on the edge of the carving for more contrast. Avoid flat light that makes the old markers harder to see and read in your photograph. And be certain your flash is off!

A treat for the history buff is the tomb of John C. Calhoun, an American vice president and significant statesman of the South. The tomb is located in the graveyard at **St. Philip's Church**. In 1865, as Charleston was about to fall to the Federal army, members of the church worried Calhoun's large tomb would provoke Union soldiers, and they would desecrate his body. To protect his remains, Calhoun's body was exhumed and placed in an unmarked grave. It remained there until 1871 when the church sexton reminded the vestry that Calhoun's body was still displaced. You will find the tomb on the north side of the church structure. The lighting is dim because of the strong shading from the church and overhanging trees, so a fill flash is a must.

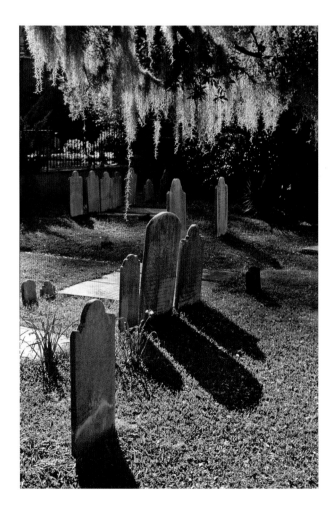

A bit removed from the common tourist routes is the old **Magnolia Cemetery** along the **Cooper River**. Relatively unknown to visitors, it is well worth the trip. Drive north on **East Bay Street** until it becomes **Morrison Drive** and joins **Meeting Street** at a stop sign. Turn right at the stop light, then right again onto **Connington Street**, following it all the way to **Magnolia Cemetery**.

In the 18th century, this land at the edge of the city was known as **Magnolia Umbra Plantation**. By 1850, it was laid out as a burial ground for Charleston's elite in the tradition of a mid 19th-century European garden. At the center is a pond with live alligators and blue herons. You will find tombs with classical and even Egyptian motifs, a crypt with stained glass, cherubs and angels, iron crosses, rusty wrought-iron fences and gnarled oak trees draped with hanging moss. Parts of the cemetery suffer from disrepair and neglect, making them even more intriguing and photogenic. Nearby are rows of Civil War tombs.

Also of note in the cemetery are the marked graves of the eight confederate soldiers who died in the submersible known as the Hunley. An experimental submarine built by Confederate forces in Charleston during the Civil War, the Hunley completed its mission, sinking the USS Housatonic, but failed to return to safety. The location of the submarine and her crew eluded divers for more than a century. After discovery, it took another three decades before the submarine was raised. The crew was finally laid to rest in **Magnolia Cemetery** on April 17, 2004, with full military honors.

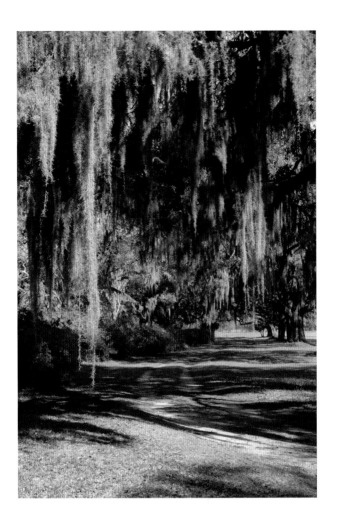

[IN FOCUS]

Backlighting

A backlit subject – one that's in shadow with the sun behind – can make a dramatic image, but it can also be tricky to take. Open up the lens two f-stops more than the meter reading for the entire scene. With a digital camera, increase the exposure higher than what the meter reads. Make sure you bracket a few exposures, using graduated f-stop settings to be sure one works.

Short Travel Adventures

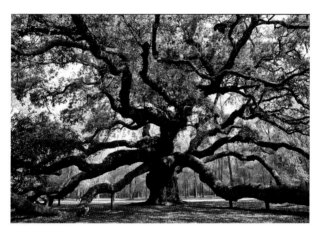

The Angel Oak Tree on John's Island

The famous **Angel Oak** on John's Island, now protected in a small city park, is purported to be the oldest such tree in the Lowcountry. Live oaks are notoriously hard to date because of their unusual trunk structure, but estimates are the tree is 950 to 1,400 years old. Its hugely elongated, arching branches, some touching the ground and covering more than 17,100 square feet, make for a fun and challenging photo opportunity.

Generally, the morning sun yields the best illumination from the south side, where you can step back far enough in this half-acre park to frame the entire tree. A wide-angle lens is a necessity – the wider, the better (e.g. 28, 24 or 18mm). Overcast days offer the extra advantage of photographing the tree without harsh shadows.

Upon arrival, visit the little gift shop where you may gain some compositional ideas from the many postcards and history booklets depicting this ancient tree. **Angel Oak Park**

is open daily, 9 a.m. to 5 p.m., and Sundays, 1 to 5 p.m. Find it on the left of **Maybank Highway** on John's Island, shortly after the intersection of **Maybank Highway** and **Bohicket Road**. Look for **St. John's Episcopal Church** (itself good photographic material), turn left onto the dirt road and proceed a few hundred feet.

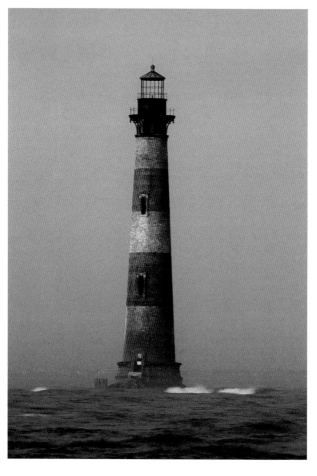

Lighthouses

What travel photographer does not love lighthouse images? The subject matter is classic and enduring; perhaps endearing is the better word. Lighthouses speak of yesteryear, but they also stand as symbols of protection in the face of hazards, strength in the face of potential adversity, and light piercing into darkness. They are universal, archetypal themes, so no wonder we preserve them, even if their function is now mostly obsolete for maritime navigation. For photographers, the theme of all our endeavors is using light to bring light to our audience. Do we not want our audience to see better?

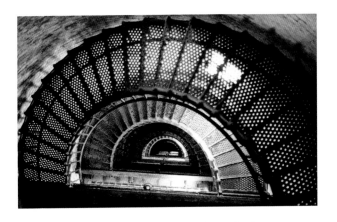

The **Morris Island Lighthouse**, located in **Charleston Harbor** just off the northern end of **Folly Beach**, was decommissioned in 1962. Lighthouses have stood on Morris Island since 1766, though the island has been lighted for navigation since colonial times (1671), using tar and pitch on the ground. In 1857, a new lighthouse was constructed, only to be destroyed during the Civil War. A decade after the war, the lighthouse was reconstructed. Over time, the churning ocean currents separated it from the island, leaving it literally stranded at sea. Today, this lighthouse needs us as much as we needed it. Stabilization of the lighthouse by the Army Corp of Engineers begins in 2007, ample evidence that South Carolinians still love this romantic landmark for its beauty and symbolism.

The lighthouse is no longer accessible by foot, even at low tide (appearances notwithstanding). Unless you have a boat, it is best photographed from the extreme northeastern end of **Folly Beach**. To view it close, pull into the public parking area at the end of **Ashley Road** and walk northeastward along the beach or up the unused road. Do so in the late afternoon when the light is at its best. Frame the lighthouse through dunes and sea oats or zoom in on it with a telephoto lens (200mm or longer). Just before sunset, the sun may paint the lighthouse gold and pink with soft colors in the surrounding sky. Or try night photography during a full moon when the lighthouse is illuminated with ambient light. The moon may also appear on the horizon behind the lighthouse.

"What I try to evoke in my photographs is the dynamic of the landscape, its spiritual and physical energy, its livingness, its essential mystery."
– John Blakemore

The more modern **Sullivan's Island Lighthouse** is the tallest lighthouse on the East Coast. Hardly an architectural gem, it shines three powerful beams. If out that way and near **Station 17** (an old tram stop numbering system), you might compose views with sea oats, sand dunes, fields of black-eyed Susan or reflections on a wet, sunset-lit beach. You can also silhouette the lighthouse against the reds or pinks of a sunset or with a crescent moon at dusk. In fog or at night, gauge the timing of the rotation of the light and catch the beams reaching outward.

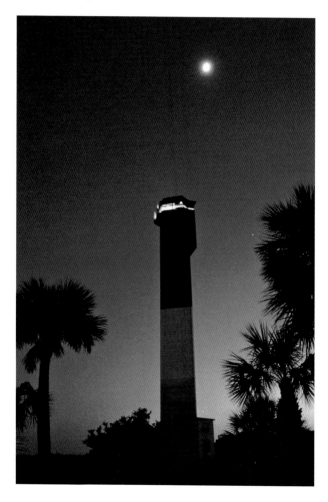

Coastal Marshes

Vast coastal marshes surround Charleston, stretching inland from the barrier islands to the upper reaches of our local rivers, abundant with egrets and cranes. Oysters, shrimp and crabs abound as do the locals who harvest them. Cast the net of your eye and camera to capture the quiet beauty. The fauna and flora can be photographed in their unaffected, natural state, without the intrusion of housing and resort developments – if you know where to go.

Marshes offer a variety of compositional options: wide-angle horizons framed with palmettos or oaks; close-ups of the color patterns of reeds and marsh grasses; docks draped in dew or fog; water fowl nesting and feeding; and locals fishing or casting shrimp nets. The right scene will speak to you, calling out for the right position and lens. Vary your lenses and use the docks and bridges or stand on top of your vehicle for higher perspective.

Bridges and elevated "connector" highways give wide vistas and sufficient height to capture the marsh waters. Most can be accessed by car, foot and bicycle. If venturing out on foot, be sure to consider the distance you're willing to walk and plan accordingly. The **Isle of Palms Connector** originates in Mt. Pleasant from **Highway 17 North** and extends to the Isle of Palms, offering excellent views of the **Intercoastal Waterway** and vast, treeless salt marshes. The causeway from Mt. Pleasant to **Sullivan's Island** affords views closer to the marsh. For dramatic views off a high arch, go to the **I-526 Beltway** and the **Daniel Island/James Edwards Bridge**.

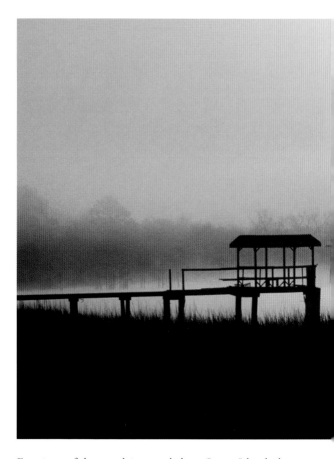

For views of the marshes in and about James Island, the **James Island Connector** starts at the end of **Calhoun Street** in downtown Charleston and hooks up to the island, providing spectacular views of **Albemarle Point** to the north and **James Island Creek** to the south.

Bowen's Island Restaurant on **Bowen's Island**, just off **Folly Road** heading toward **Folly Beach**, is a place to take in engrossing views from the dock over the marsh facing the setting sun. You may find a few shrimp boats, egrets and brown pelicans to add to your composition. The restaurant, legendary for its rough-edged idiosyncrasies, recently was rebuilt after a devastating fire destroyed it and the accumulated decades of graffiti scribed on the walls by locals, notables and the famous who enjoyed the view, steamed oysters and beer.

"Things were looking for me, I felt – just calling to me"
 –Walker Evans

[IN FOCUS]

Timing Photography in the Marshes

1 Use the golden "sweet light" of early morning and late evening; midday colors are flat.

2 Watch the tide tables and take your pictures at higher tides. At that time, the waters rise up to the marsh grasses, covering the otherwise muddy and less attractive marsh banks.

3 Observe the curving streams winding through the grasses and include them for interesting compositions.

4 Consider shooting in the twilight hours of dawn and dusk, and at high tide. These hours can provide richly colored skies, bathing the marsh waters with wonderful reflections. It's a sight to behold, especially if there's a crescent moon on the horizon. Much of great nature photography comes from simply getting there and being there.

For other close views of the marshes, try **River Road** on
John's Island, going in the direction of **Kiawah Island**. Even
better are the expansive views along the entry road directly
into **Kiawah Island**. For a day trip, travel south on **Highway
17** past **Jacksonboro** in the direction of Savannah, and there
you can view and explore the marshes of the **ACE Basin**
(so-named for its three rivers – the **Ashepoo**, the **Combahee**
and the **Edisto**). This is the largest protected wildlife refuge
in a saltwater marsh on the East Coast, with expansive and
spectacular marsh views. And my final recommendation is
the highly scenic **Toogoodoo Road** on **Yonges Island**, where
you'll encounter undisturbed views around every bend. As
always, the back roads are best.

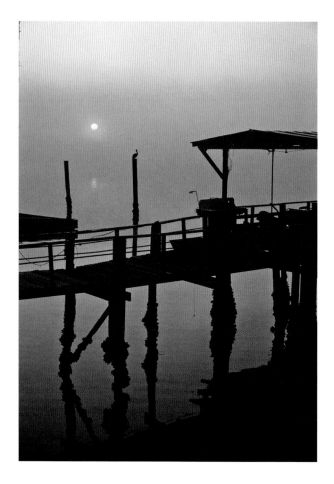

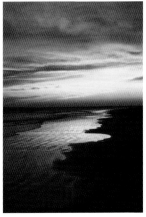

Beaches & Dunes

Ocean beaches closest to downtown Charleston (**Folly Beach** to the southeast and **Sullivan's Island** to the northeast) are enduring subject matter. A mere 20-minute drive from the city, these beaches inspired my love of photography some three decades ago and planted the seeds of what became my second career. I remember walking alone, enchanted by the rippled sand dunes swept by warm ocean winds, the soft pastels of dawn and dusk, the movement of the shrimp boats and freighters chugging in and out of the harbor, the mysticism of the sun piercing the early morning fog. For me, walking the beach and working to capture its subtle character has been meditative and healing. What a way to watch, to see and to contemplate.

Let these beaches speak to and bring out the artist in you. Take time to stroll and observe. Frequent the beaches as often as possible, and at the more unusual times, for the sake of capturing their ever-changing, infinite moods. Go beyond the predictable midday "post card" views. Venture out at twilight, or just after a storm, or the half hour after sunrise, at moonrise, or when a crescent moon is setting.

[IN FOCUS] ────────────────

Saturated Colors

Slightly underexposing your shot can increase the saturation of the colors. The easiest way to do this with a film camera is to set the camera's light meter one notch higher than the ISO of the film, e.g. from 50 to 80. Another way is to slightly underexpose the image, giving the image just a bit less light than the meter calls for.

The beaches around Charleston run diagonally from the northeast to the southwest, amplifying opportunities for capturing both sunrises and sunsets. Don't be misled into thinking that, if there are beach sunrises, there are no beach sunsets. The bends and curves of the sea islands and coast afford views from an array of vantage points.

Now for a few compositional ideas that are not immediately apparent. Catch the morning or evening colors reflected in the tidal pools stranded by receding tides, sometimes shallow enough to expose a ribbing in the sand. Shoot the rising or setting sun through the sea oats, even with a telephoto lens for tight, simple compositions. Meter down and the sea oats will silhouette. Watch for groups of brown pelicans gliding low over the water and pull them into your compositions. If you choose to capture human activity, there is sand castle building, kiting, surfing, and couples walking into the sunset.

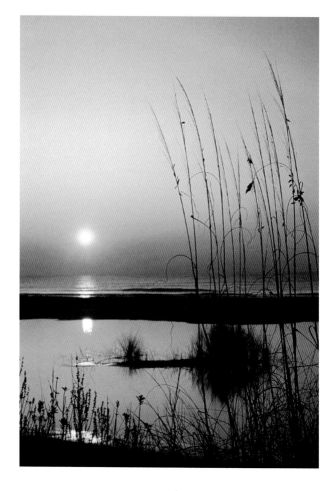

Even in the dark, you can capture the moon edging up over the horizon with its light shimmering on soft waves in the foreground. Of course, you will need a tripod and a fast ISO setting, but it will work for this romantic image.

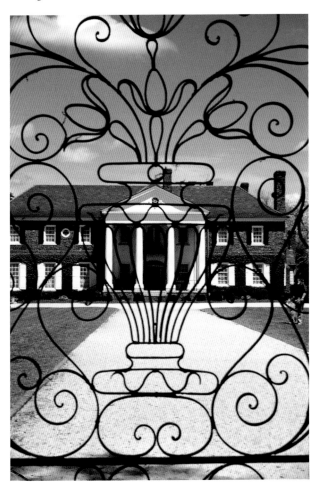

Plantations

The plantations of Charleston offer a provocative array of scenes and subject matter, evoking a way of life long past. Knowing and understanding the history behind the aging walls, spent rice fields, ironworks, cotton fields, worn porches and massive live oaks will inform your photography in a way that "pointing and shooting" never can. Rather than merely record what you see, let your photography tell a story.

Drayton Hall, closest to Charleston, is west of the **Ashley River** on **Highway 61**, also known as **Ashley River Road**. It is the only original 18th-century plantation house in the Charleston area to survive the Revolutionary War and

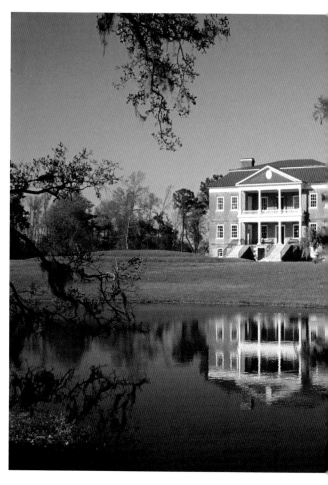

Civil War intact. Built between 1738 and 1742, the house is considered to be one of the oldest and finest examples of Georgian-Palladian architecture in America. The most captivating and often-captured photograph here is of the house reflected in a small pond on the grounds, framed by an arching oak tree at the pond's edge. Another excellent view can be found from the checkered portico, viewing the grounds and oak tree lane through the portico's columns. On the riverside, a good shot can be found through the front door, viewing the river through its wrought-iron banister. Keep in mind that flash photography is not allowed inside the house.

Magnolia Plantation and Gardens feature vast and magnificent informal flower gardens with bridges and statuary, a natural cypress swamp filled with wildlife, peacocks and livestock, a river rice boat, a slave house and a grand mansion. The gardens flower through most of the year with

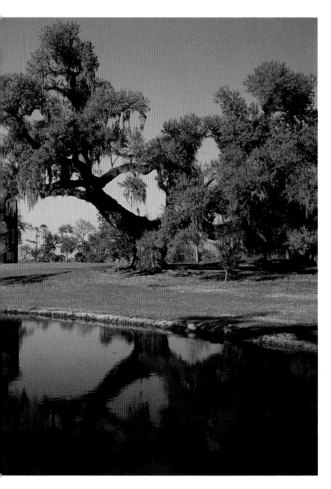

an abundance of camellias in winter and azaleas in spring. Come with plenty of film and/or camera "memory." You'll want it.

If you take the house tour, a small room on the second floor offers a lovely view of **Magnolia Plantation's** avenue of oaks. I shot a scene here once, framing it with old, colored bottles sitting on the windowsill at the time. I won a prize for that photograph. Ask for permission and use a tripod for plenty of depth of field.

Middleton Place Plantation and Gardens are America's oldest formally landscaped gardens. Built in 1741 by Henry Middleton, president of the first Continental Congress, this historic plantation is a few miles further up **Highway 61**. Here, you'll find 70 acres of gardens laid out in geometric patterns with delightful vistas over the **Ashley River**. Again, as at **Magnolia Plantation**, bring plenty of film.

Subject matter and compositional opportunities are endless, including countless azaleas and camellias (the oldest camellias in the country); lakes, ponds and statuary; oak trees with hanging moss; grazing cows and sheep; and a re-enacting blacksmith, weaver, carpenter and cooper in the farmyard. Bring all your equipment and allow at least half a day, especially in the spring and fall.

Some of my favorite scenes at **Middleton Place** are the white swans on the upper garden lake with azaleas reflecting in the pond's waters; the old rice mill reflected in one of the garden's famous "butterfly" lakes; and **Eliza's House**, a 19th-century freeman's cabin complete with interior furnishings.

Boone Hall Plantation in Mt. Pleasant is most notable, in my opinion, for its grand avenue of oaks (planted in 1743) and the row of nine brick slave houses (1790-1810). So, once you drive in and park, walk back up to the entry with your gear and compose.

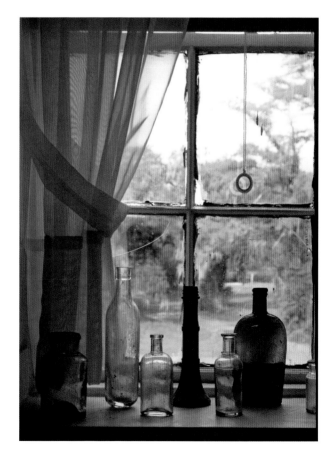

Still a working plantation, **Boone Hall's** plantation house is a 1935 rebuild, but it is the picturesque, stereotypical Southern mansion, often used as a movie set. Good photographs can be taken of the plantation house through the mansion gates in front of the lawn. Open the gate slightly to catch its design elements. This plantation is very much worth the price of admission and, as at the other plantations, especially in the springtime.

8 Final Shots

The Harbor's Edge

Photographic opportunities can sometimes be found literally at the doorstep of the historic peninsula itself. The constant comings and goings of people in and out of the city tend to disguise obvious compositions, in this case the harbor's edge. It says much about the city and its special appeal now, as it has through the centuries of maritime activity.

First, to get our bearings, let's sketch out the possibilities that await you. At the mouth of the harbor is **Fort Sumter**. Then, along the Charleston edge of the harbor are **Waterfront Park, S.C. Port's Authority Passenger Terminal**, the **Maritime Center, Fort Sumter National Monument Museum** and **Tour Boat** facility, and the **S.C. Aquarium**, in that order. After that, moving across the water toward Mt. Pleasant, is the picturesque **Arthur Ravenel Jr. Bridge**, **Patriot's Point** with the **Yorktown aircraft carrier** and, finally, **Shem Creek** and its shrimp boat fleet. Allow me to highlight a few for you.

Historic **Fort Sumter**, sitting at the mouth of **Charleston Harbor** and seriously damaged during the Civil War, offers some photogenic subject matter. My favorites are the remaining brick archways and wooden doors around the base of the structure. The fort is reachable daily by tour boat from its terminal at **Liberty Square**, adjacent to the **S.C. Aquarium**.

The **Maritime Center** and the **S.C. Port Authority's Passenger Terminal**, one block off **East Bay Street**, occasionally host visiting historic tall ships, with towering masts, rigging and sails. Here, take in the range of angles, from all-inclusive wide-angle vessel shots to close-ups of the hardware and rigging. When in port, these ships catch the afternoon sun at either location. If you're fortunate, you just might catch these historic beauties coming or going in the harbor.

The new **Arthur Ravenel Jr. Bridge** that spans the **Cooper River** is totally delightful for photography, be it viewed from afar or from up on its pedestrian walkway. From the Charleston side, the best vantage points are from the upper, outdoor decks at the **S.C. Aquarium**, the **Fort Sumter** tour boat facility, or the second floor deck at **Fountain's Walk**, all near each other at the very eastern end of **Calhoun Street** (**Aquarium Wharf**, **Liberty Square** and **Fountain Walk**). Midday and afternoon sun capture the bright white lines of cables, and late evening sun captures them in gold. Another dramatic view, late in the day with colorful sunsets and the skyline of the city, is from **Remley's Point** in Mt. Pleasant just north of the eastern end of the bridge. And, if you choose to walk the bridge, you'll obtain the grandest view of all the harbor and city, especially early in the morning when the city is bathed in golden "sweet light."

Patriot's Point and the World War II aircraft carrier **Yorktown** present the photographer with real challenges. The morning sun illuminates it best, along with the skyline of Charleston in the distance. Evening and dusk light yields silhouettes of the ship and the Charleston skyline. Onboard, a wide-angle lens helps to capture the aircraft assembled on the massive flight deck, and afternoon sun is most effective. While at **Patriot's Point**, walk past the complex to the parking lot adjacent the nearest hotel, up onto the wharf toward the water, and a clear view of the city skyline becomes visible, with images that can be framed by rows of small sailing boats.

Shem Creek in Mt. Pleasant flows into the harbor and hosts most of the area's shrimp boat fleet. Views can be captured from the open decks at several of the restaurants at **Shem Creek** or from the docks on either side. Nautical details

and paint textures on the boats will present themselves to you, as well as brown pelicans perched on pilings. You can also walk the **Coleman Boulevard Bridge** for a wider view. Early morning light illuminates the scene warmly, foggy mornings give those classic mood shots, and sunsets give infinite varieties of color tones in the sky and color casts on the water. Meter your exposure for the sky or water, and the shrimp boats will come out as strong silhouettes.

"I remember what has happened in my life through moments that I remember visually."
–Dorothea Lange

Skylines from the Water

The skyline of Charleston, still relatively "European" with its church steeples etching the sky, is protected by a rule that no new building can be built taller than **St. Philip's Church**. The skyline can be photographed from afar; however, it takes a bit of choreography. Grab your camera bag, long telephoto lens and tripod, and try one of these locations.

One view, best in the late afternoon, is from the **James Island Connector**. By that time, the city's skyline turns golden from the low angle of the sun. To find an ideal spot, drive onto the bridge from the city, then double back in order to get on the harbor side of the roadway. Slow down, find your preferred view, pull over into the side/emergency lane and set up your tripod. If the tide is high, you can combine the channeled marsh grasses with the skyline and steeples in the distance. If you want the city marina in the picture, travel further along this same road, stopping just before the connector's final exit.

A morning view of the skyline appears best from the marina next to the **Yorktown at Patriot's Point**. Cross the **Cooper River bridge** to Mt. Pleasant, and drive past the **Patriot's**

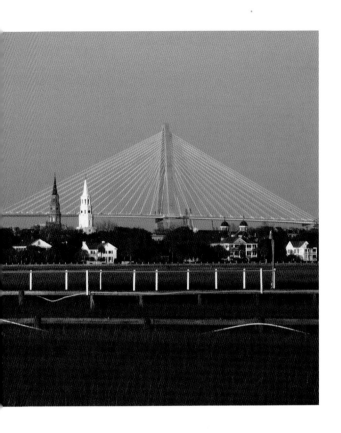

Point parking lot to the next unpaved parking lot on your right (next to the **Charleston Harbor Resort & Marina**). There's a boardwalk to the marina where you can frame the city's skyline with a variety of pleasure craft in the foreground. It's also a good location for a sunset behind the city with steeples in silhouette.

You might also frame a skyline view from **Charleston Harbor's** open waters on board a boat. The tour boats that offer views of the harbor and **Fort Sumter** are a good way to gain the skyline view. Be aware that, when you get too close to shore, cruising past **The Battery**, for instance, the steeples will disappear behind the city buildings and houses. With enough distance from the shoreline, you'll achieve a handsome skyline shot.

Travel to James Island along **Harborview Road**, and a complete skyline will appear with marsh in the foreground and the two white towers of the **Arthur Ravenel Jr. Bridge** arching above the city. The view brings together the charm of this historical city with its modern, futuristic bridge.

Afterword

My hope for you, the user of this book, is that your photographic adventures give you some memorable creative opportunities. As you connect to Charleston and its environs with your eye and lens, I hope you also tap into your own power for creative expression.

Quality in photography as an art is a merger of subject matter, play of light, right equipment and the creative impulse. As in inspiring music, art or theater, these combined elements produce a quality that can take the ordinary and make it extraordinary.

Recall: "We receive the light; then we impart it." You've gone for the light in Charleston; now it's time to present and share it. Enjoy!

– Ron Rocz

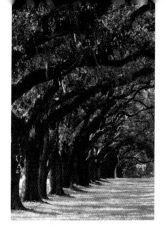

A Short Glossary of Terms

Aperture
An adjustable iris in the center of the lens both in film and digital cameras.

Aperture Setting
The size of the lens opening through which light passes, indicated by f-stops (e.g. f-5.6 or f-8) on a ring around the lens close to the camera body or in the readings of a digital camera.

Back Lighting
Light that comes from behind the subject, toward the camera.

Composition
The proportional arrangement of the elements of an image that results in pleasing aesthetic qualities, e.g. balance. Or, in the words of the famous photographer Edward Weston, "The strongest way of seeing something."

Cable Release
A long cord that attaches to a camera's shutter release, releasing the shutter without touching the camera; helps avoid vibrations that can blur an image.

Center-Weighted Metering
In-camera metering of only the light coming through the lens into a designated circular field at the center of the viewfinder screen – hence, weighted for the center. This kind of metering is more concentrated than an "average" overall metering of the scene.

Converging Vertical Lines

A lens aberration that causes straight lines at the edge of an image to appear curved and leaning inward toward the center of the image. These converging lines are often seen in the viewfinder when tilting the camera lens, especially wide angle lenses, upwards to photograph buildings.

Crop (in camera)

To trim the edges of an image, often to improve the composition by moving the camera's position.

Depth of Field

The distance between the nearest and farthest points from the camera that are acceptably sharp and in focus. Smaller aperture openings, e.g. f-16, yield greater depth of field; larger openings, e.g. f-4, yield less depth of field.

Film Speed

The relative sensitivity to light of a film or a digital camera's CCD senor, as measured by an ISO rating, e.g. 100, 200, 400, etc.

Flash Fill

Light from a flash that lightens shadows on the subject matter, reducing the contrast ratio.

ISO

A rating that describes the sensitivity of film to light or, in the case of digital cameras, the camera's CCD sensors to light. The higher the ISO rating, e.g. 400, the "faster" the film or digital camera sensor is, giving more "grain" in the film or "noise" in the digital image. Lower ISO ratings are thoroughly adequate for daylight shooting.

LCD

Liquid crystal display. (Tip: extensive use of this display on a digital camera, instead of the viewfinder, will drain the camera's batteries much faster.)

"Open Up"

To increase the size of a lens aperture, e.g. to open up from f-8 to f-4, thereby letting in more light but decreasing the depth of field.

SLR
Single lens reflex camera.

"Stop Down"
To decrease the size of a lens aperture, e.g. to stop down from f-8 to f-16.

Shutter Speed
The speed at which the camera shutter opens and closes, allowing light to strike the film or digital camera sensor, measured by parts of a second or more.

Short Telephoto Lens
Any lens with a long focal length, drawing the subject matter closer to the camera, as in "telescope," ranging from 50 to 200mm.

Tungsten Light
Light from an incandescent light bulb, i.e. house lamps. In the case of film cameras, good photography requires special tungsten film and, in the case of digital cameras, a setting for tungsten lighting.

Wide-Angle Lens
A lens that is 35mm or "wider," which increases the field of view, e.g., a view of the subject matter greater than the human eye.

White Balance
The kind of light, or "whiteness," in the immediate environment, e.g. sun light, shade, tungsten, etc. Digital cameras give "WB" settings in the menu.

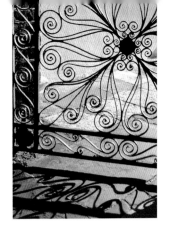

The Photographer's Offerings

Photographic Prints
A large collection of Charleston photographic prints, including those in this book, are available for purchase in all sizes, matted or framed. Many can be viewed on Rocz's web site at www.ronroczphoto.com. Prints are also available at his Broad Street studio by appointment.

Posters
The poster "Patterns of Charleston" (20" x 30") is available for purchase.

Photography Walking Tours
Photography walking tours are available upon request, with individual and group rates. Consultations and reviews of photographic work for constructive feedback also can be arranged.

Feedback on This Book to the Photographer
The photographer welcomes comments and feedback from the readers, as well as suggestions and corrections for future editions. Call or e-mail.

Ron Anton Rocz
170 Broad Street, #1
Charleston, SC 29401
843-577-9236
843-906-6896 cell
www.RonRoczPhoto.com
ronrocz@attglobal.net

Acknowledgements

I wish to acknowledge all those friends whose encouragement and assistance contributed immensely to the creation of this book. They include Norman Blackman, for his initial and insightful consultation; Ruth Miller, Valorie Perry and Michael McLaughlin, for historical information and editing; Patricia Bower, for her creative textual suggestions; Michael Craven for technical input; John Davis for editorial refinements; Lee Helmer for artistic consultation; and Carolyn Goldinger, for encouragement and editorial feedback. A special thanks goes to the folks at Joggling Board Press, especially editor Susan Kammeraad-Campbell and historian Douglas Bostick, for their enthusiastic support of this project idea and their professional creativity in bringing this into being. And to designer John Costa, whose excellent design sense brought this project "in focus." Most importantly, I acknowledge Melvyn Smith, whose vision it was that I create this book in the first place.

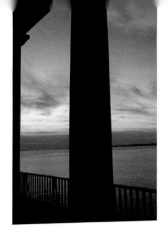

Index

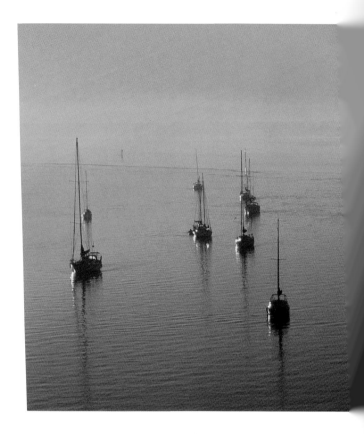

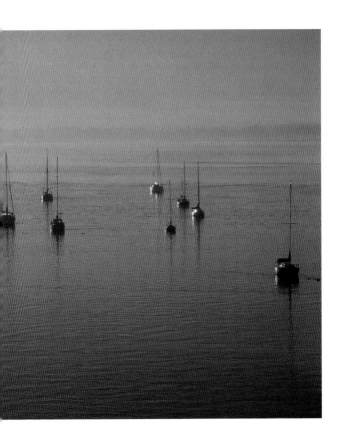

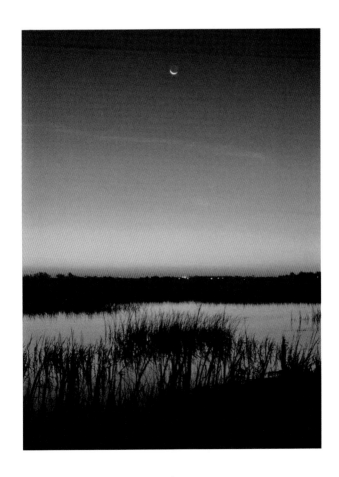

141

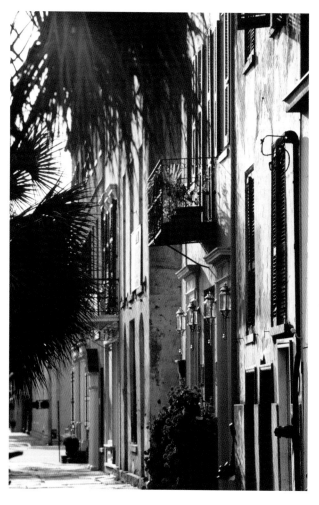

"Two qualities essential for a great photographer
(are) insatiable curiosity about the world, about
people and about life, and a precise sense of form."
 –Brassai